**This book is to be returned on or before
the last date stamped below.**

1 3 OCT 2009

Auguste

Rodin

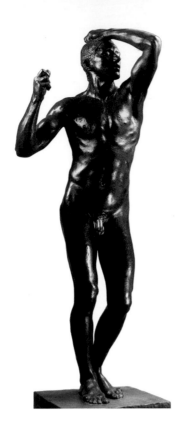

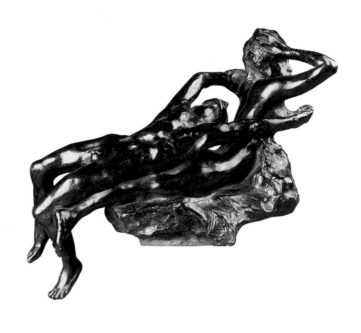

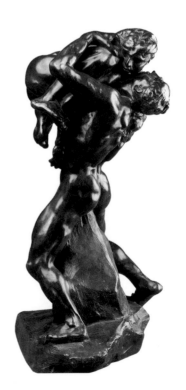

Published in 2004 by Grange Books
an imprint of Grange Books Plc
The Grange Kingsnorth Industrial Estate
Hoo, nr Rochester Kent ME3 9ND
www.Grangebooks.co.uk
ISBN 1-84013-653-7
Printed in China

Auguste

Rodin

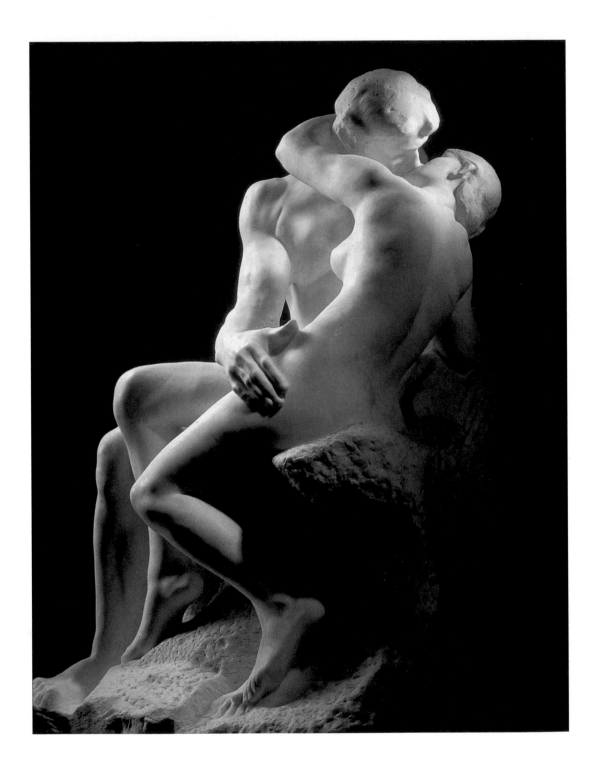

At the principal annual art exhibition, the Salon, in Paris in 1898, the sculptor Auguste Rodin exhibited two enormous statues - *The Kiss* (p. 4) and *Balzac* (p. 17). He was fifty eight years old and nearing the height of his fame. It was both a challenging gesture and a typically brave response to professional and private adversity. Originally the embracing couple in *The Kiss* had been envisaged on a much smaller scale to take their place on a massive pair of doors commissioned from the French government for a projected new museum of decorative art. Rodin had been working on the doors, known as *The Gates of Hell* (p. 6), for almost twenty years; but by 1898 it had become clear that the museum would not be built. That year, Rodin enlarged the couple massively in marble for the Salon.

The *Balzac* sculpture was another failed public monument, initially commissioned by a literary society in 1891 to commemorate the titanic nineteenth-century writer. After seven years of preparatory study, Rodin had decided to exhibit the work to reassure his critics that the project was nearing completion. When the committee responsible for the work saw it at the Salon, roughly cast in plaster, they rejected it and terminated their contract with him.

Certainly both works, so antithetical in style, discharge conspicuous erotic energies - a blatant indication that this element of the erotic, of sensual force and sexual primacy were central to Rodin's life and work. Of course the differences between the two works are immediately the more striking. If it still surprises us to know that both these works were made by the same man, the well-dressed Parisian crowds who saw them prominently on view at the Salon were equally, if not more, nonplussed.

The Kiss is smoothly carved in gleaming white marble, its massive lovers presented as idealized and divinely beautiful protagonists. The *Balzac* on the other hand, crudely cast in plaster (other versions in bronze and marble were made later), is powerfully ugly, with its jagged profiles, rough textures and a more or less complete disregard for anatomical detail, accuracy and finish. In *The Kiss* the entwined couple enact a titillating, almost comic encounter. The figures were originally inspired by Dante's lovers Paolo and Francesca, damned eternally for incest, but here revealing nothing of their awful, poetic fate (Rodin made another, darker version for the doors). It is the woman who has initiated proceedings - while she forthrightly embraces her lover and has moved her right leg over onto his lap, he only tentatively touches her left hip. (In his own love affairs it was usually Rodin who made the running).

1. ***The Kiss***, 1888-1889.
Marble,
Musée Rodin, Paris.

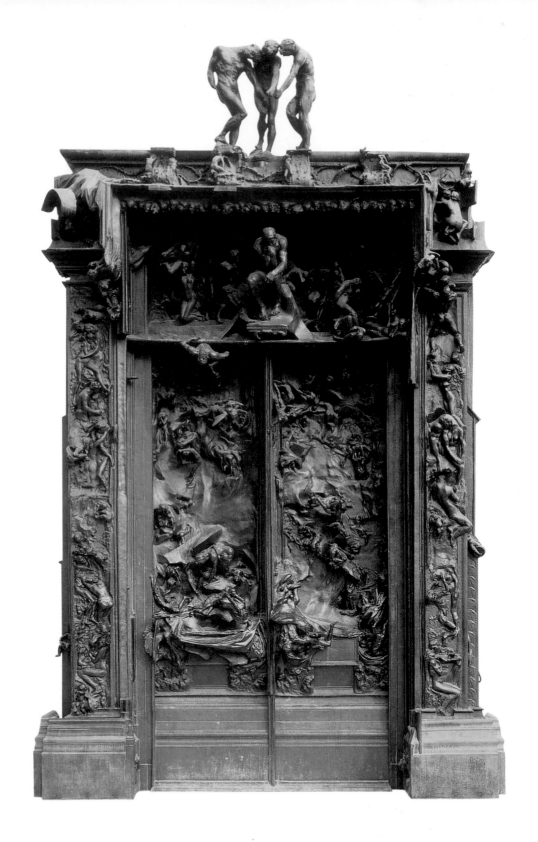

2. ***The Gates of Hell***,
1880-1890/95.
Bronze,
Musée Rodin, Paris.

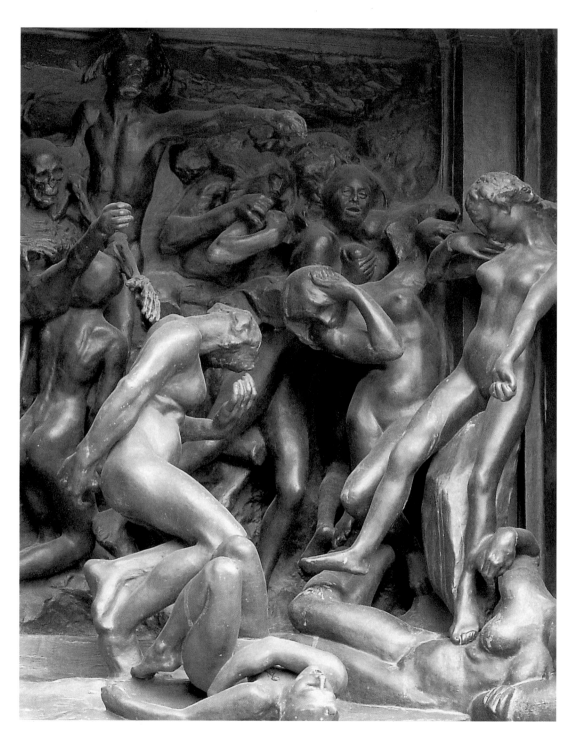

3. ***The Gates of Hell***,
 lintel detail. Bronze.

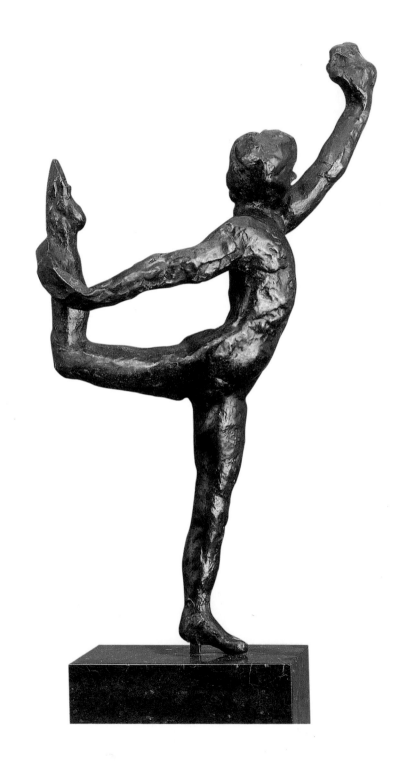

4. ***Dance Movement.***
 Bronze.
 Musée Rodin, Paris.

5. ***The prodigal Son***,
 circa 1886.
 Plaster,
 Musée Rodin, Paris.

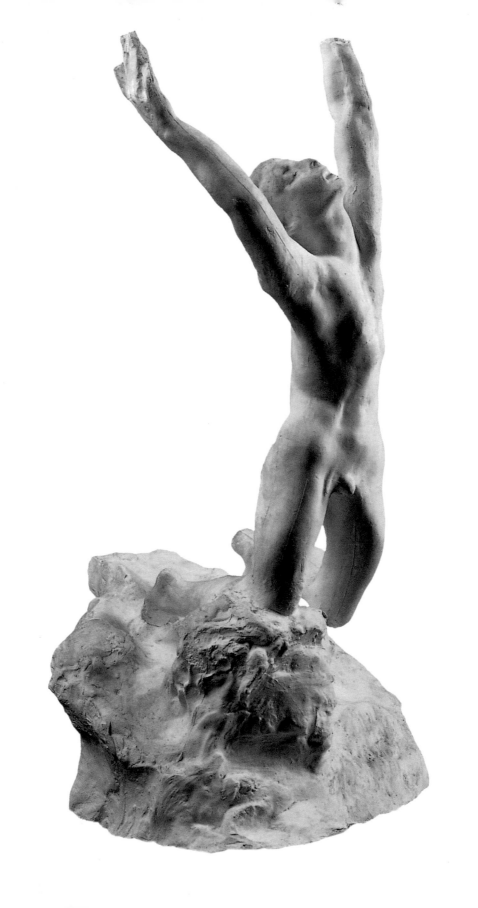

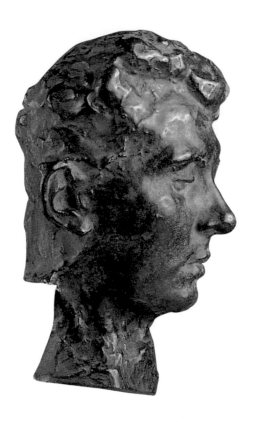

The *Balzac* (p. 17) offers no comparable narrative interest. Veering off the vertical this enormous, distorted figure twists with terrifying force upwards - more an expression of the writer's (and the sculptor's) creative powers than a literal description of Balzac's physical appearance. 'A monument, not a monsieur reproduced in stone,' as Rodin himself put it.

There is, however, much that the works share. Both have been the subject of scandal and violent disapproval. A slightly earlier version of *The Kiss* (p. 4) was removed from an exhibition in Chicago in 1893 because the frank nature of the couple's embrace was considered too candid a sexual prelude for public taste to accept.

6. ***Rose Beuret***,
 circa 1890.
 Bronze,
 Musée Rodin, Paris.

Even as late as 1952 there was strong opposition to the Tate Gallery in London buying a copy for permanent display.

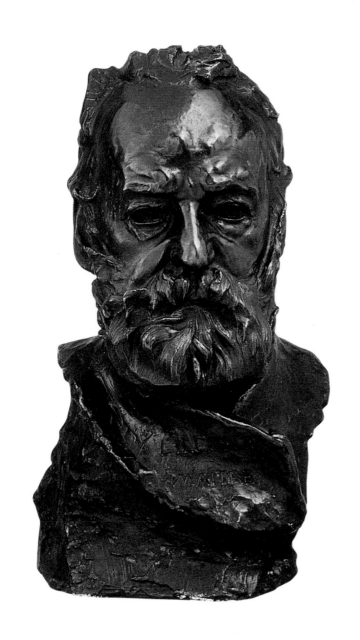

7. *Victor Hugo*, 1883.
Bronze,
Musée Rodin, Paris.

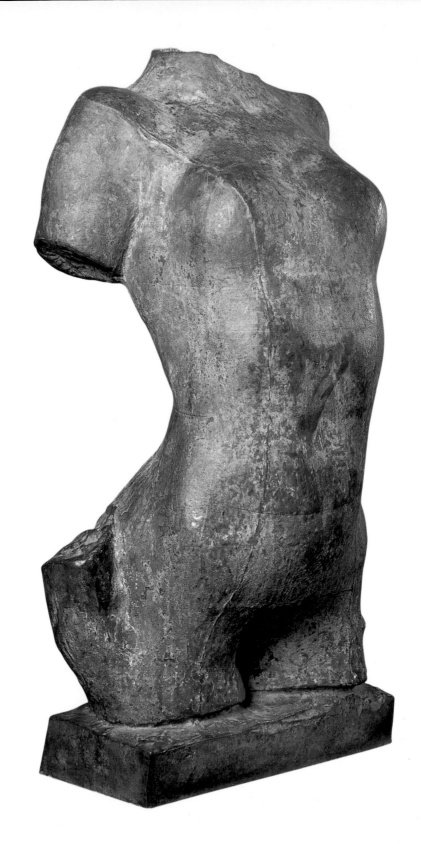

8. ***Torso of a Young
Woman***, 1910.
Bronze,
Musée Rodin, Paris.

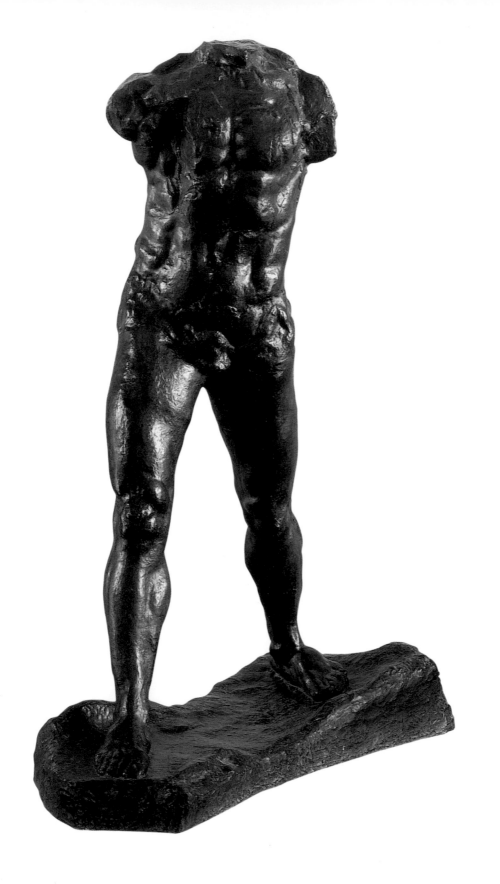

9. *The Walking Man*,
1900-1907.
Bronze,
Musée Rodin, Paris.

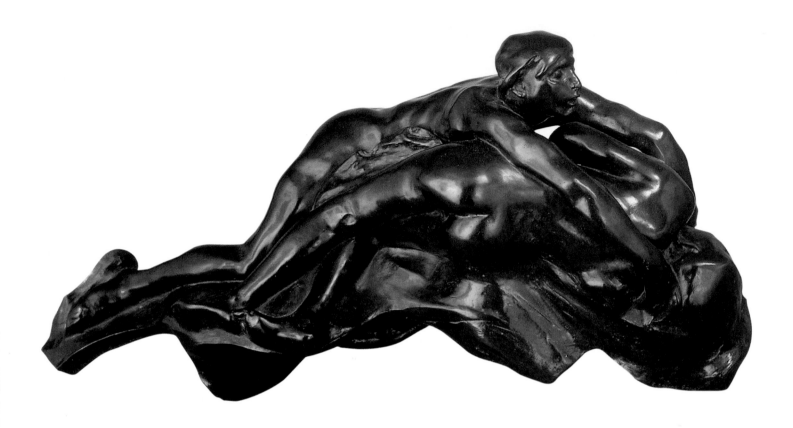

10. *Paolo and Francesca*,
 circa 1886.
 Bronze,
 Musée Rodin, Paris.

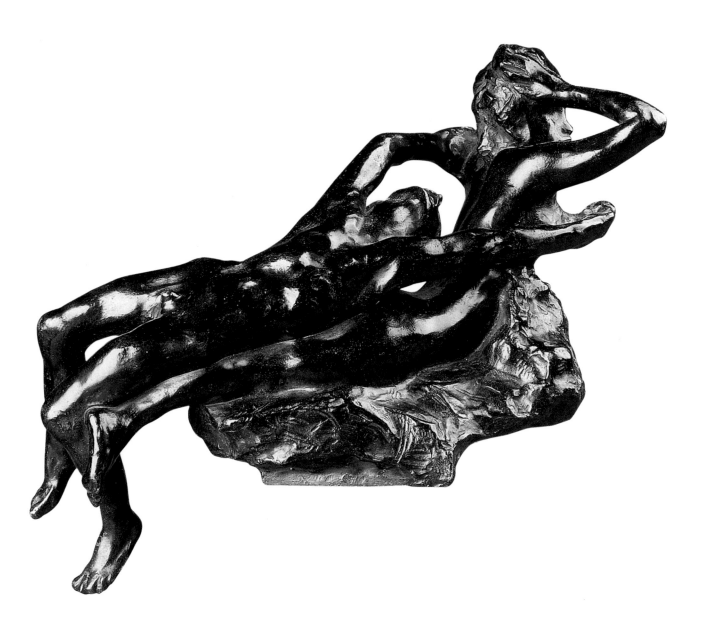

11. ***Fugit Amor***,
 circa 1884.
 Bronze,
 Musée Rodin, Paris.

The *Balzac* (p. 17) was rejected by the committee who had commissioned it, describing Rodin's monolith as 'a shapeless mass, a nameless thing, a colossal foetus.' Others at the time called it 'a toad in a sack'.

The novelist Emile Zola and a number of other prominent public figures supported Rodin and petitioned the Parisian authorities to buy it for the city, but to no avail. The controversy was caught up in the explosive political storm then dividing French society: the Dreyfus affair, in which the State stood accused of complicity in anti-Semitic discrimination against a Jewish officer serving in the French army. Those who maintained that the government had acted dishonourably supported Rodin and the two issues were linked in the press.

What was probably considered most shocking about the statue was more rarely acknowledged. In a preparatory nude study for the piece, which was subsequently cast in bronze as an independent work, Rodin modelled a figure with his hands held together clasping his erect penis. The final *Balzac* is clothed - draped with a dressing gown that seems to seethe with seismic force. (Balzac, when he wrote, worked sixteen hours a day, ingested vast amounts of tobacco smoke and coffee and wore a dressing gown). But beneath its folds, a prominent bulge suggests strongly that this Balzac seems to be doing exactly the same as his predecessor.

Moreover the form of the whole is distinctly phallic. Both sculptures then share, at their heart, a dominant sexual motive power. This force is essential to much of Rodin's art and is mirrored in many of the stories recorded about the man himself. These concentrate on his physical presence (despite or because of his small stature), his sexual energy, his hands, his piercing blue eyes, his heavy step.

The American dancer Isadora Duncan, for example, describes how she invited the great sculptor to her studio in the early years of this century, where she performed one of her dances for him (he was in his sixties, she in her twenties): 'He began to knead my whole body as if it were clay, while from him emanated heat that scorched and melted me. My whole desire was to yield to him my entire being, and indeed I would have done so if it had not been that my absurd upbringing caused me to become frightened and I withdrew and sent him away bewildered . . . What a pity! How often I have regretted this childish miscomprehension which lost to me the divine chance of giving my virginity to the great god Pan himself, the mighty Rodin.'

12. ***Balzac in Dominican Robe***, 1892-1895.
Plaster,
Musée Rodin, Paris.

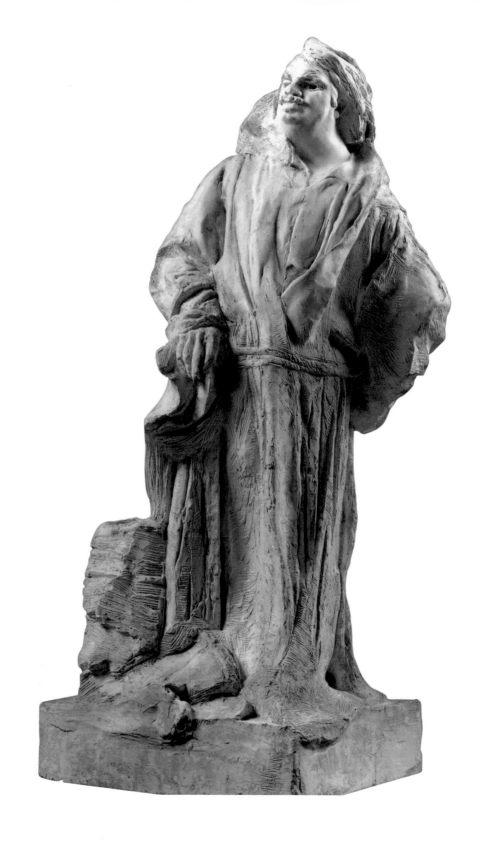

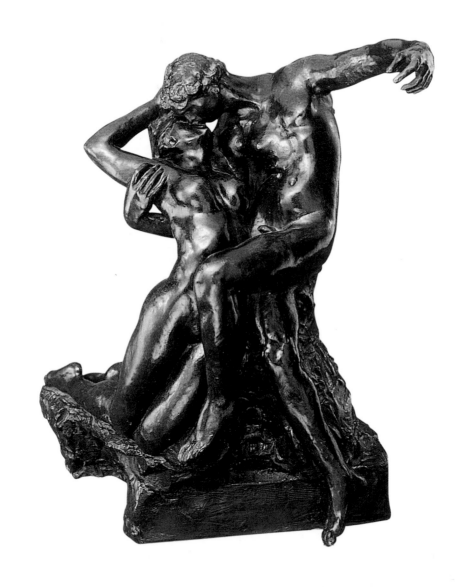

The prolific French diarist Edmond de Goncourt likened Rodin to a libidinous faun and recounted how at dinner with Monet and the painter's four daughters, Rodin had looked at each of them so directly that out of embarrassment one by one they left the table.

Another anecdote tells of Rodin reverentially kissing the stomach of a female model posed for him in his Paris studio (which is exactly what Pygmalion is doing to Galatea in Rodin's sculpted version of this myth); the English playwright George Bernard Shaw relates how Rodin would take a huge draught of water in his mouth and spit it out onto the clay to keep it moist. The German writer Stefan Zweig describes Rodin at work in his old age (none of these stories, incidentally, concerns Rodin's younger years):

'Then he no longer spoke. He would step forward, then retreat, look at the figure in a mirror, mutter and utter unintelligible sounds, make changes and corrections. His eyes, which at table had been amiably attentive, now flashed with strange lights, and he seemed to have grown larger and younger. He worked, worked, and worked with the entire passion and force of his heavy body; whenever he stepped forward or back the floor creaked.'

It is such physical, sensual and on occasion overtly sexual details as these which impressed themselves on his contemporaries. His sculptures have had a comparable effect on later viewers. The British sculptor Henry Moore, who never met Rodin, remarked once in conversation: 'It [the erotic] is certainly very important for Rodin, though it doesn't interest or excite me very much. But for Rodin I think this erotic excitement was a part of his rapport with the human figure.'

The Sensual Surface

This excitement is immediately evident in the surfaces of Rodin's works, in particular his bronzes. They exude a sensual malleability, a fluent and vivid play of light and shade; they quiver and dance in a state of anatomical liquefaction. They seem to invite our own tactile response. And here it is worth recalling that Rodin worked primarily as a modeller. His marbles were largely speaking carved by assistants, copying bronze or plaster originals. Rodin himself very rarely cut or hacked or chiselled (*La Tempête, p. 66; L'Aurore*).

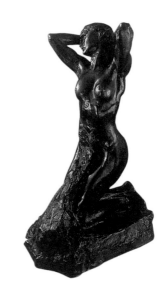

13. *Eternal Spring*, 1884.
Bronze,
Musée Rodin, Paris.

14. *Venus Awakening*,
circa 1887.
Bronze,
Musée Rodin, Paris.

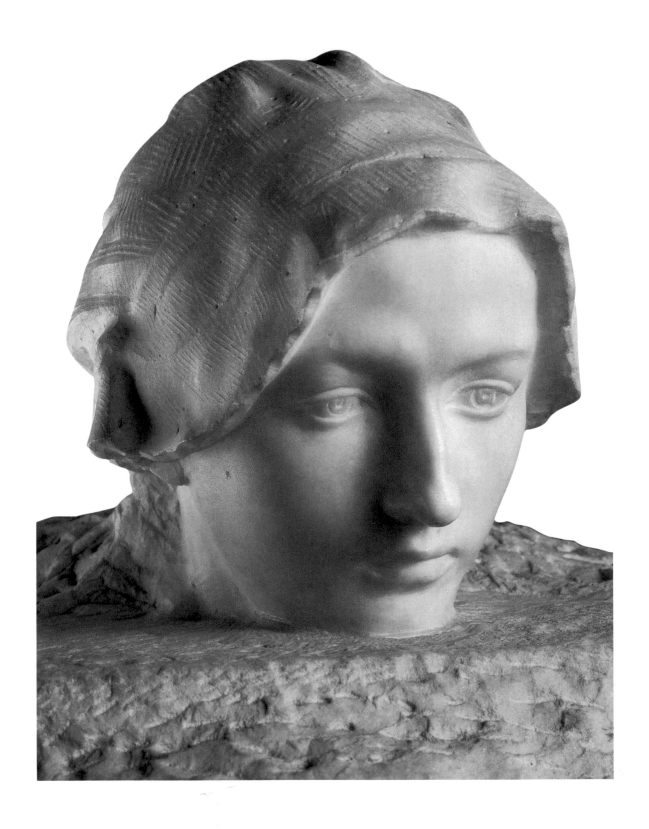

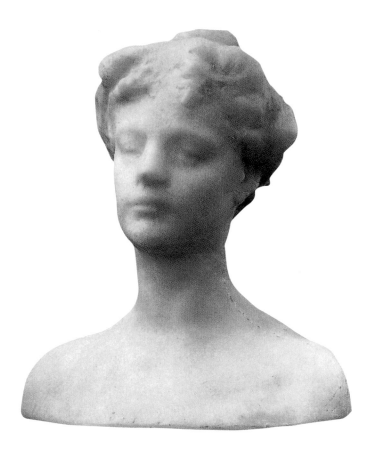

Instead, he pressed, rubbed, smoothed, caressed and moulded wet clay with his hands. The clay figure would then be cast in either plaster or bronze. The process of working was for him inherently manual, digital, ductile and seductive.

Works such as *Eternal Idol*, *Vertumne et Pomona*, *Toilette de Vénus*, *Torse de Jeune Femme* (p. 12) and *Eternal Spring* (p.18) make manifest this debt to an erotic muse both in the poses of the figures and the texture of the finish.

In the beginning none of this was quite so clear. Rodin's erotic liberation was to come later in his life. 'I did not know that, distrusted at twenty they [women] would charm me at seventy. I distrusted them because I was timid,' he is recorded as saying. In fact the details of Rodin's early life have a seriousness and austerity about them that would seem to exclude any erotic or sexual inspiration.

15. ***The Thought***, 1886.
Marble,
Musée Rodin, Paris.

16. ***Hélène Nostitz***,
circa 1902.

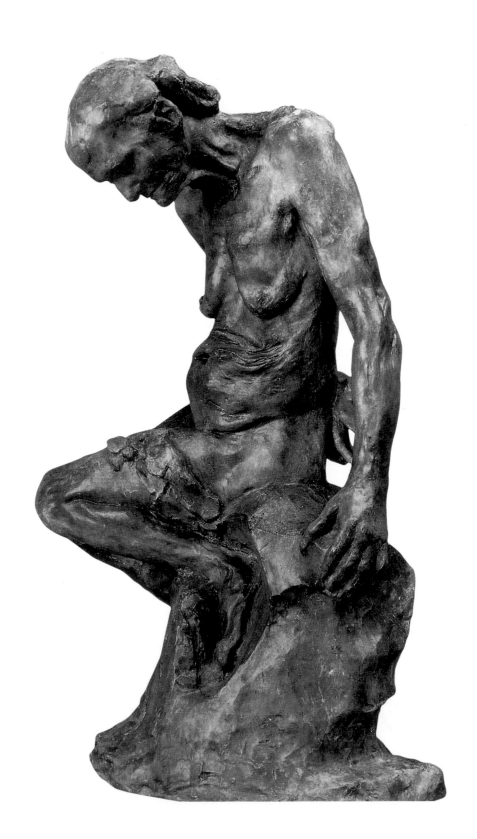

17. ***The Helmet-Maker's
Wife***, circa 1887.
Bronze,
Musée Rodin, Paris.

18. ***The Crouching
Woman***,
circa 1881-1882.
Plaster,
Musée Rodin, Paris.

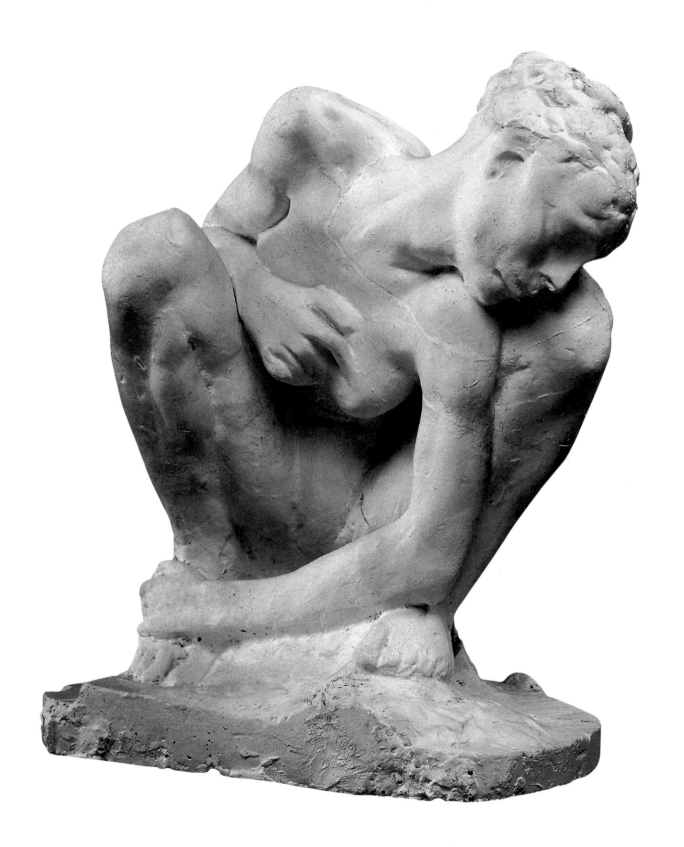

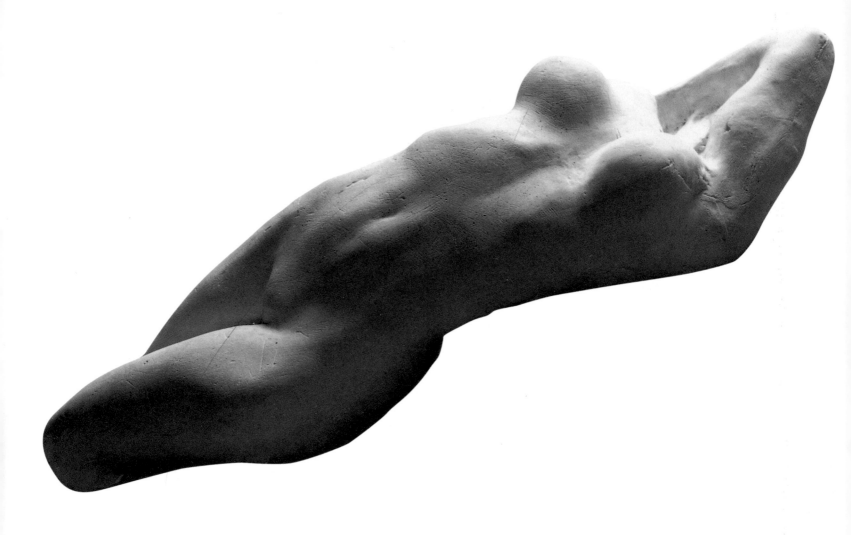

19. ***Torso of Adèle***, 1882.
 Plaster,
 Musée Rodin, Paris.

20. ***Torso of Adèle***, 1882.
 Plaster,
 Musée Rodin, Paris.

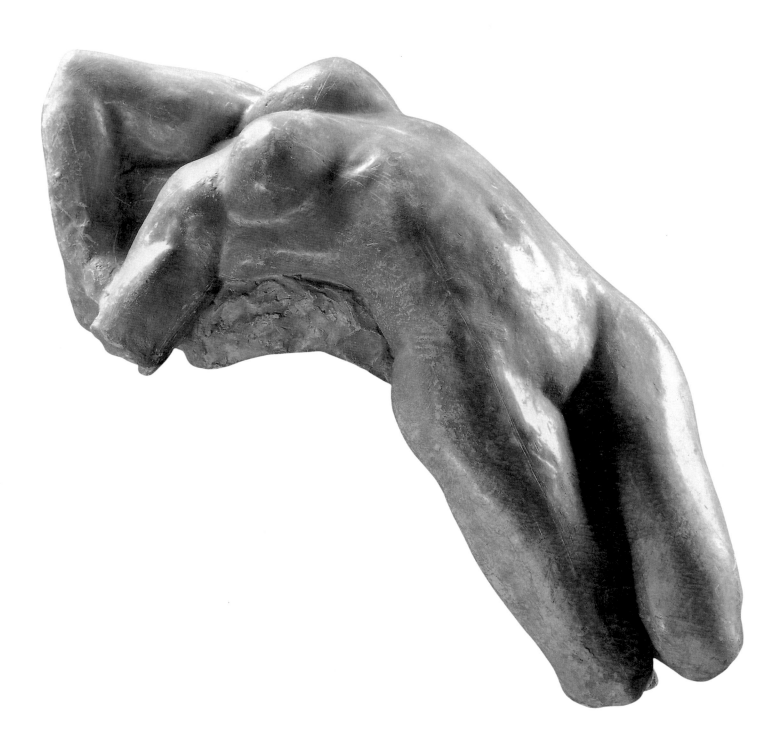

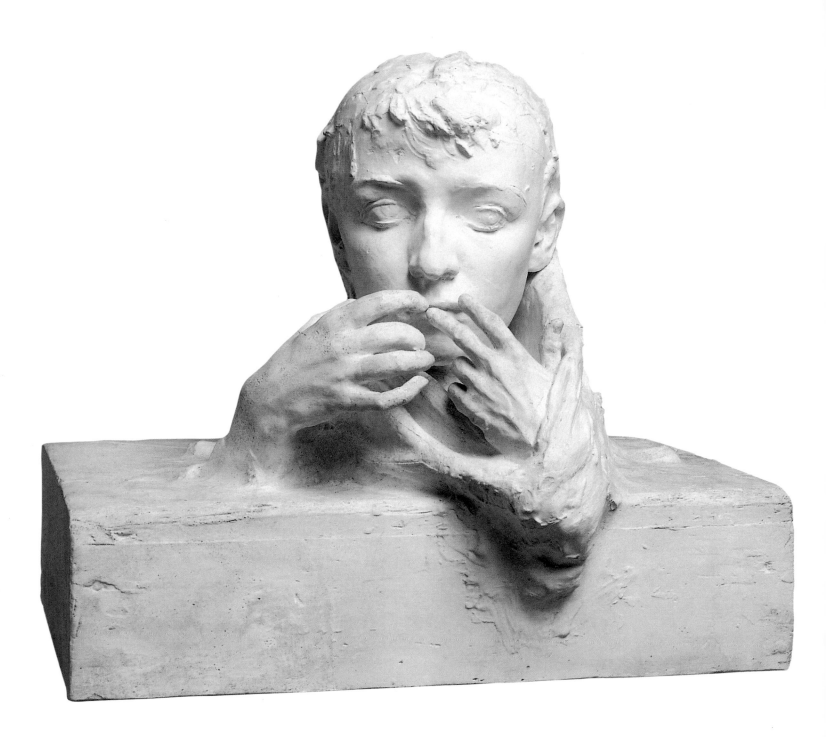

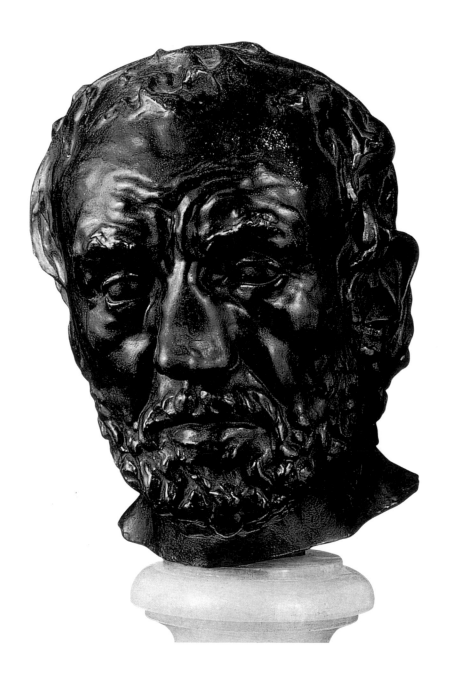

21. *The Farewell*, 1892.
 Plaster,
 Musée Rodin, Paris.

22. *The Man with the*
 Broken Nose, 1864.
 Bronze,
 Musée Rodin, Paris.

Rodin was born (1840) into a poor, hard-working Parisian family. His father disapproved of his son's desire to become a sculptor. Rodin was forced to study in his own time while he supported himself by producing pretty rococo-style sculptures as an assistant in a large, commercial studio. As a young man he also spent a year in a religious institution as a novice after his sister died, although he never took orders.

Rodin's first romantic and sexual experiences had no direct effect on his earliest independent sculptures, which share a robust virility both in style and subject - male nude figures and male portrait heads. During his twenties he met a young girl, called Rose Beuret, herself twenty years of age, in a sweet shop. She was a seamstress, they became lovers and in 1866 she bore him a son whom Rodin more or less completely ignored for the rest of his life. She and Rodin never separated; she was to die only a few months before him. And despite all the affairs and assignations that Rodin was to enjoy once he had lost his timidity, they finally married in 1917, both in their seventies, two weeks before she died.

The words of a short note he wrote to her in 1913 speak of a loyalty and warmth that extended over fifty years: 'Ma bonne Rose, je t'envoie cette lettre comme une réflexion que je fais de la grandeur du cadeau que Dieu m'a fait en te mettant près de moi. Mets ceci dans ton cœur généreux. Je reviens mardi.' Who knows whom he might have been with on Monday; but Rose never deserted him. Rose modelled for Rodin, but cannot properly be described as an erotic muse: this was a role to be filled by his other mistresses, one above all the others. Their early years together were in any case marked by poverty and hard work.

In addition, the outbreak of the war with Prussia in 1870 forced the couple to leave for Belgium so that Rodin could find work to support them. They only returned to Paris in 1877. France's defeat in the war with Prussia had brought with it the fall of the régime. The emperor Napoleon III was deposed, the Second Empire collapsed and the Third Republic inaugurated in its place.

A corresponding change in taste away from the impersonal, rhetorical styles favoured under the Empire provided a cultural climate in which the private, emotional and intimate character of Rodin's art was at least more likely to find a sympathetic audience.

23. *Fallen Angel*, 1895.
Bronze,
Musée Rodin, Paris.

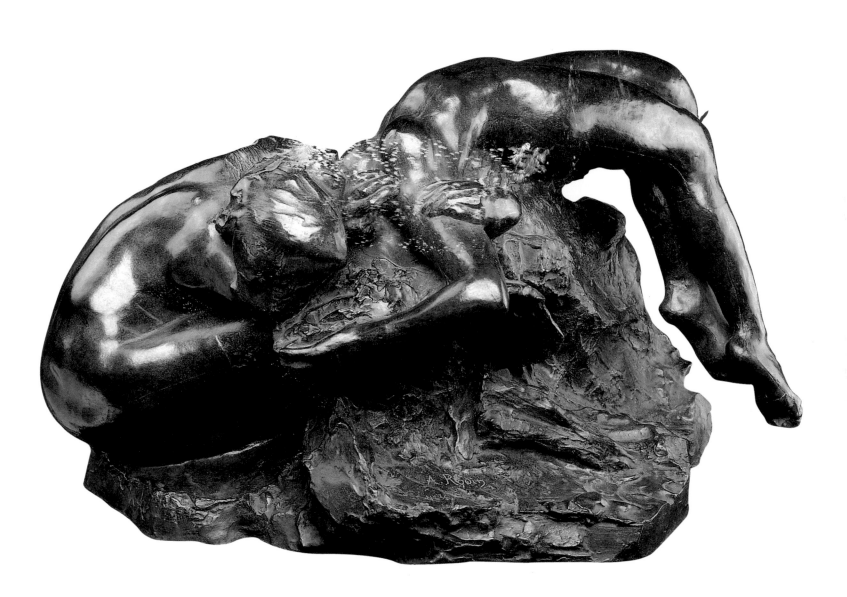

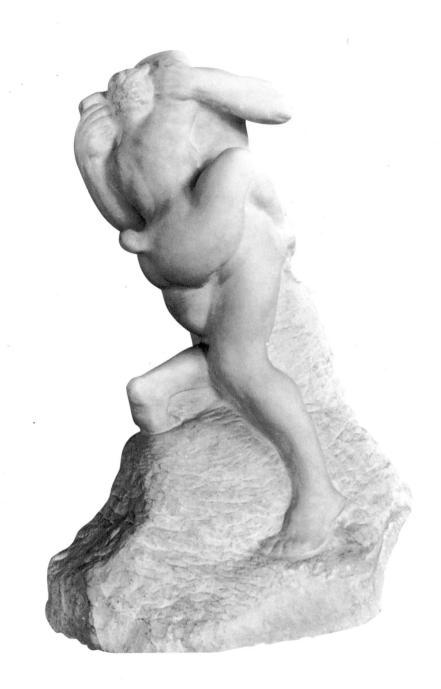

24. *The Rape.* Marble.

25. *"The Falling Man"*
on a Corinthian
Capital, circa 1885.
Plaster,
Musée Rodin, Paris.

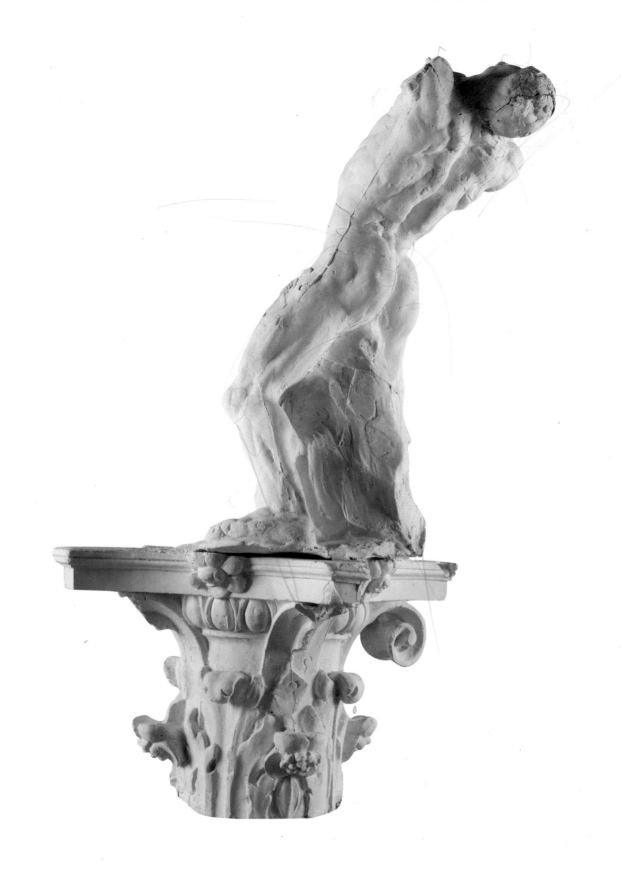

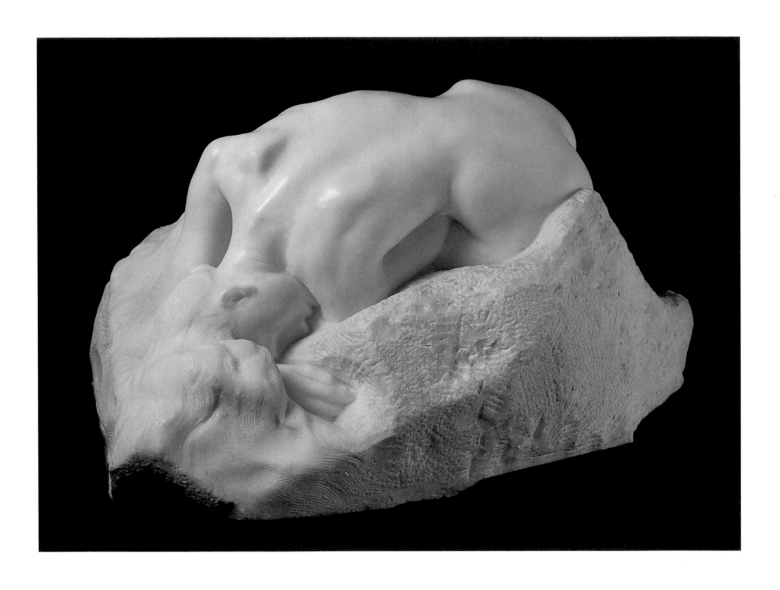

Just as his independent statues began to be exhibited, not without controversy, in Paris he won an important public commission (1880) to sculpt a pair of figuratively decorated doors for a new art museum - subsequently to become known as *The Gates of Hell* (p. 6).

The state provided Rodin with a large, well-equipped studio in Paris, as well as with coal for heating during the winter months. It was Rodin himself who had chosen the theme - Dante's epic journey through hell in *L'Inferno*. Few of the figures on the doors however can be related directly to the poem, which served Rodin more as a point of departure than a as programme to be followed.

The Gates, in other words, became the expression of Rodin's private vision of tormented humanity. The initial inspiration for the project was acutely pessimistic: the human form was to become the expressive vehicle for inconsolable spiritual distress. The doors are presided over by three figures at the top, who are about to enter the underworld, and by the figure of *The Thinker* (p. 73), representing the poet himself - powerless and alone as he contemplates the vortex of suffering and anguish beneath. Rational orderings of space, scale and narrative have been dissolved as figures and setting define themselves in terms of fluid, energised despair. Most chillingly, there are no devils on the doors - the source of all this pain is self-inflicted; and there is no redemption.

Over many years Rodin experimented with them, constantly adding or adapting the figures (186 in all). Many were later enlarged and recast as independent pieces. The project was to remain unfinished at Rodin's death (1917); but it was while working on *The Gates*, in 1883, that he met Camille Claudel, twenty years his junior. She was one of a group of students who had come to his studio to learn from him. It was at this point that Rodin's work began to celebrate overtly sexual subjects and to parade erotic sources of inspiration.

26. ***Danaid***, circa 1889.
Marble,
Musée Rodin, Paris.

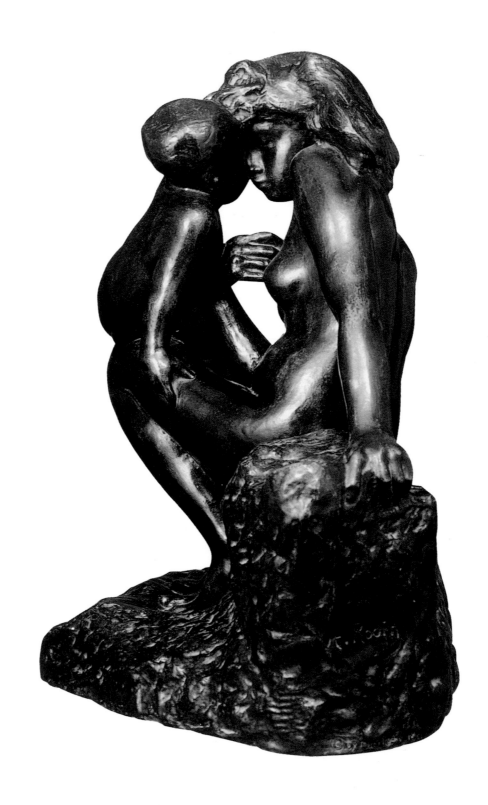

27. *The Young Mother*,
1885.
Bronze,
Musée Rodin, Paris.

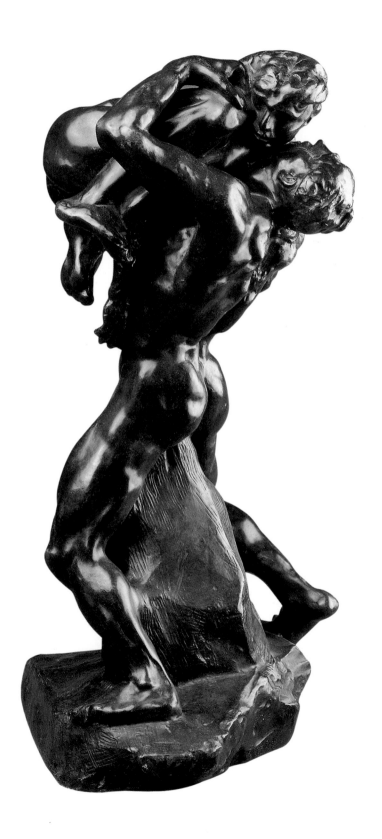

28. *I am beautiful*, 1882.
Bronze,
Musée Rodin, Paris.

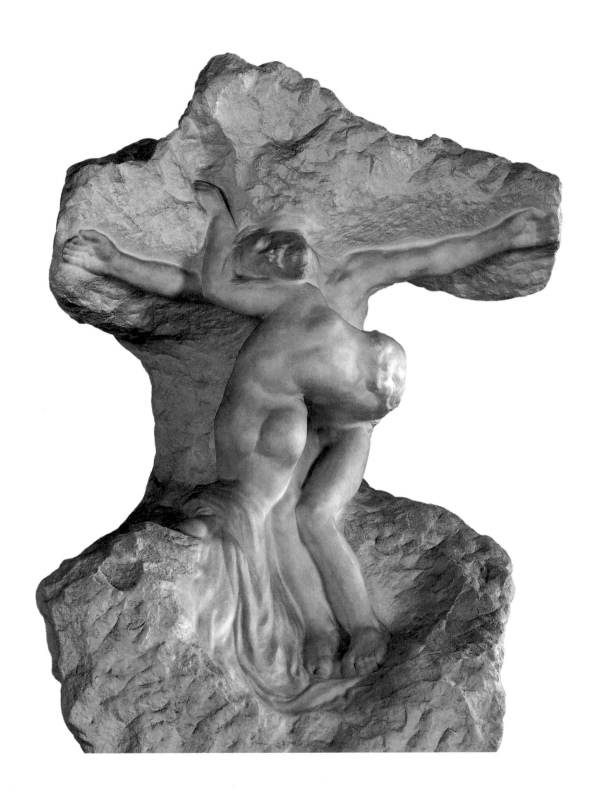

29. ***Christ and Mary
Magdalene***, 1894.
Marble,
Musée Rodin, Paris.

30. ***The Hand of God***,
1896.
Marble,
Musée Rodin, Paris.

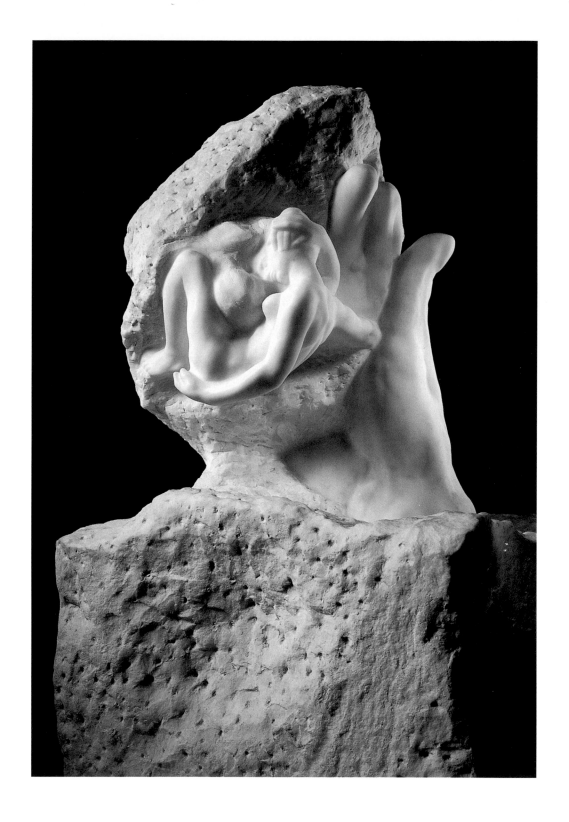

In many ways, she was an ideal companion for him; not simply because she, too, had magnificent blue eyes nor that her family also disapproved of her pursuing an artistic career. Spirited, independent-minded and passionate, she was more than gifted in her own right as a sculptress. The writer Octave Mirbeau, a friend of Rodin's, described her as 'une révolte de la nature, une femme de génie'. Their affair lasted for fifteen years.

Through most of the 1880s and 1890s, Camille Claudel's impact on Rodin's creative life was far out of the ordinary. She seems to have precipitated its transformation. For four years she worked as Rodin's permanent assistant on *The Gates* (p. 6), after which she pursued her own independent career. Erotically conceived figures now began to take their places in the scheme for the doors.

Many, in addition to Paolo and Francesca in *The Kiss*, were subsequently turned into independent works - *Fugit Amor* (p. 15), *Paolo and Francesca* (p. 14), *Meditation, Torse d'Adèle* (p. 24, 25), *Femme accroupie* (p. 23). Camille Claudel also modelled for a number of other works: *La Pensée* (p. 20), *Danaid* (p. 32), *Head of Camille Claudel*. She is like none other of the many women connected with Rodin. Of all his muses she was the most fecund.

Inevitably Rose suffered; and there were, it is said, many jealous confrontations between the two women. Rodin, however, never lived openly with Camille even if for protracted periods he did stay away from Rose. Ultimately it seems that Camille Claudel probably finished the relationship because of Rodin's refusal to leave Rose.

Whatever the case, her life after Rodin was one of cruel suffering: she spent the last thirty years of her life in a mental asylum (she died in 1943). Her brother, the poet Paul Claudel never forgave Rodin and described him (understandably) in unflattering but also familiar terms: 'He had the big, bulging eyes of a lecher.

31. ***Iris, Messenger of the Gods***, 1890-1891.
Bronze,
Musée Rodin, Paris.

When he worked he had his nose right on the model and the clay. Did I say his nose? A boar's snout, rather, behind which lurked a pair of icy blue pupils.' (In fairness, it should be noted that Rodin was extremely shortsighted and needed to get close to his models).

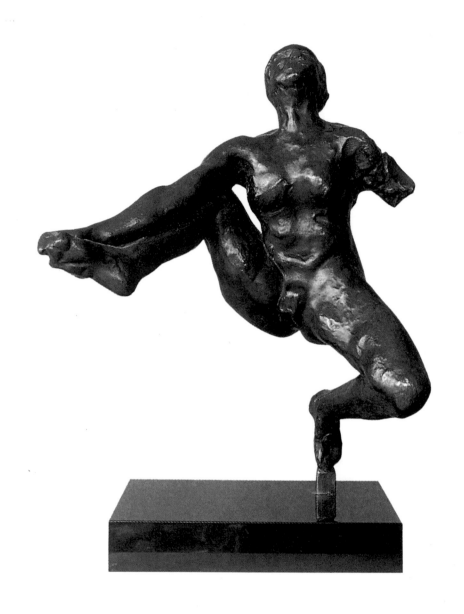

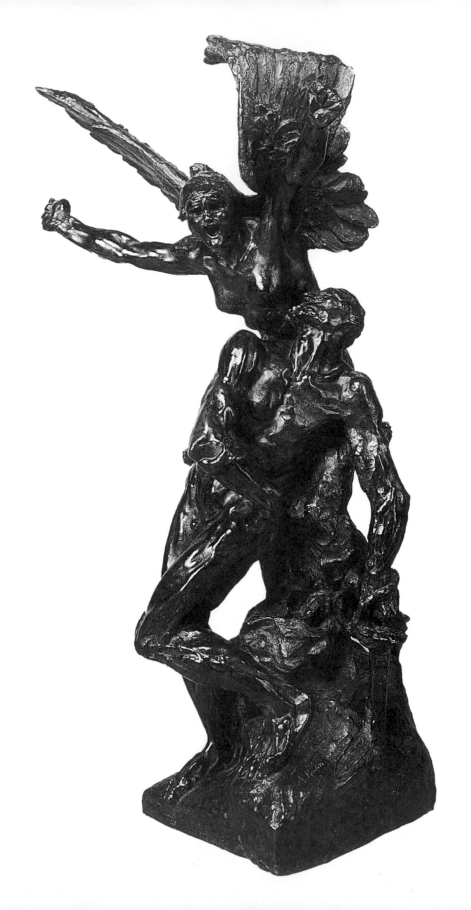

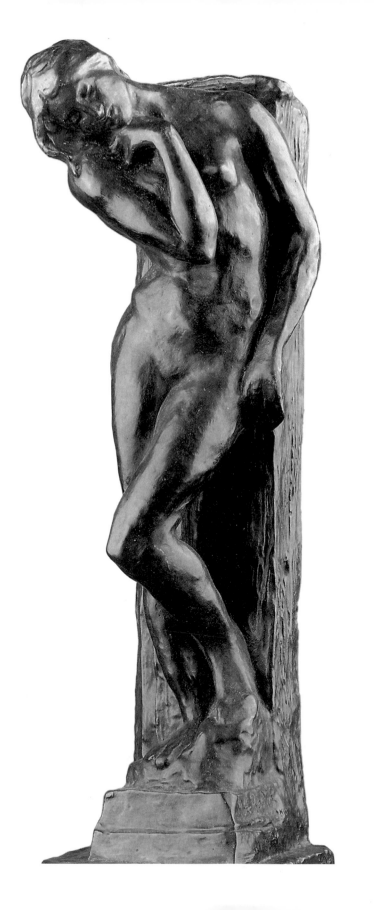

32. ***Call to Arms***, 1879.
 Bronze,
 Musée Rodin, Paris.

33. ***Eve at the pillar***.
 Bronze,
 Musée Rodin, Paris.

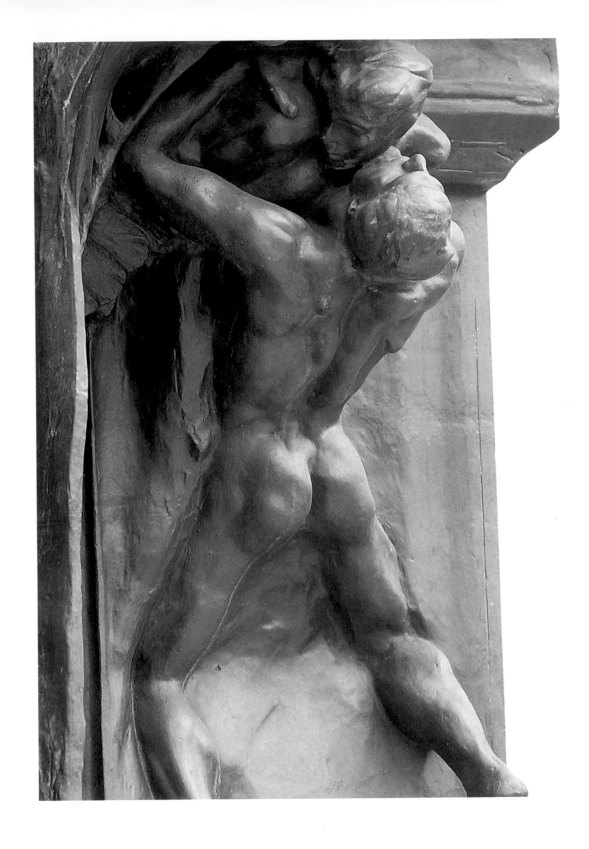

34. *The Gates of Hell*, detail. Bronze.

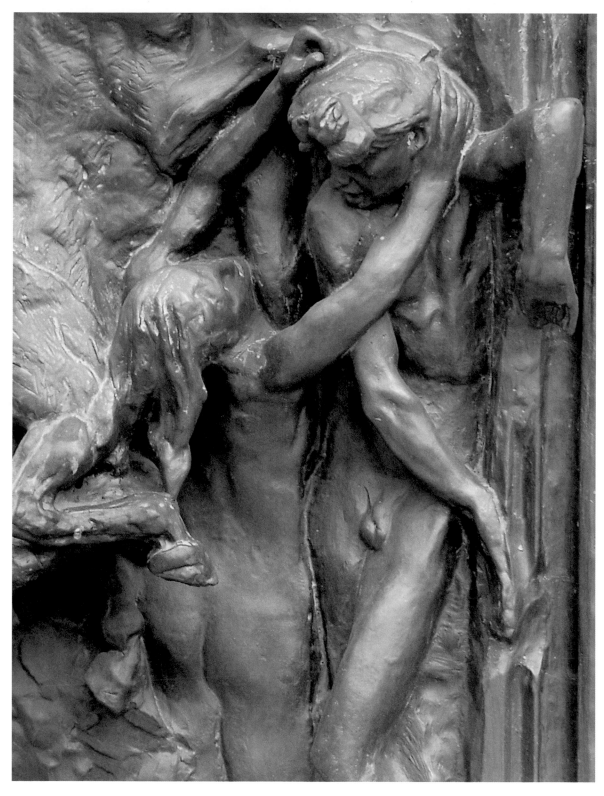

35. *The Gates of Hell*,
detail. Bronze.

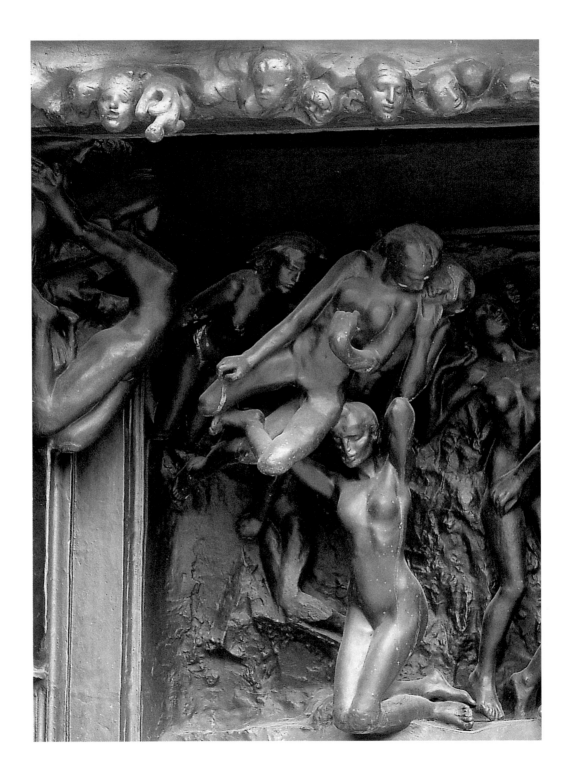

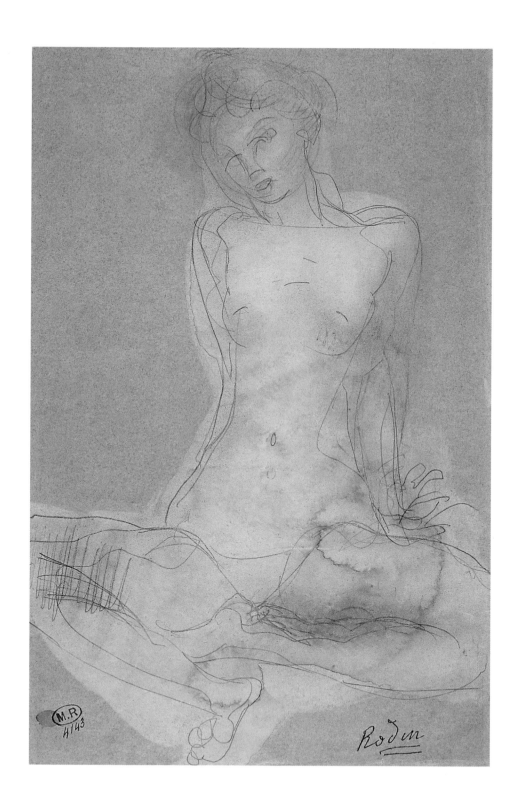

38. *Seated Woman*.
Lead, watercolour and
stump on paper.

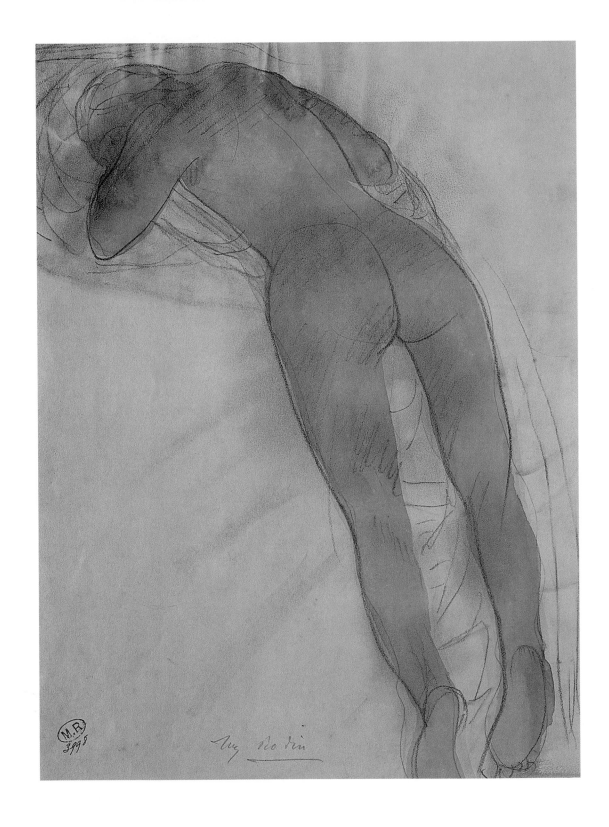

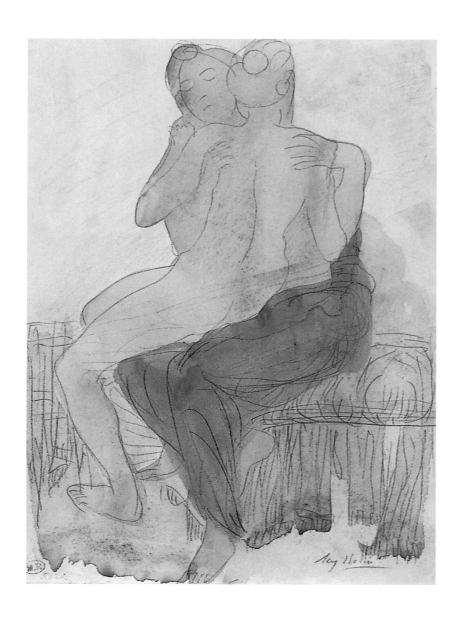

39. ***Nude Woman Lying
 on her Stomach***.
 Lead and charcoal on
 paper.

40. ***Seated Sapphic
 Couple***, circa 1910.
 Lead, watercolour and
 gouache,
 Musée Rodin, Paris.

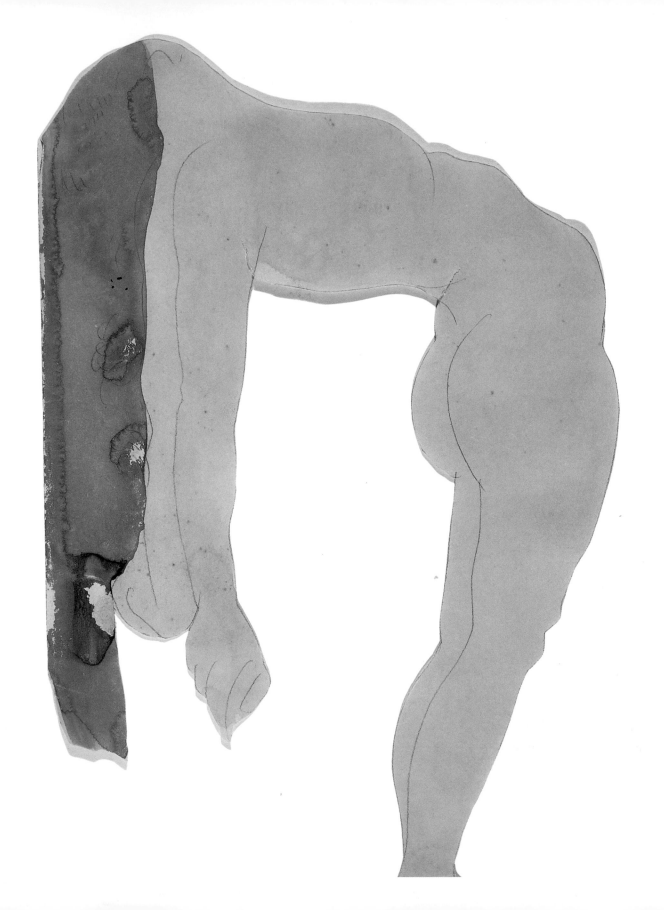

A few were made by tracing from the original onto another sheet - so as to eliminate superfluous lines as a further means of simplification; some were cut out and recombined with other figures.

This method of working was highly unusual - both for its speed and freedom. Rodin did not look at the page while he was working. Neither did he ask his models to hold any particular pose. Instead he drew as they moved freely around him, letting each finished sheet fall to the floor as he began another. The daring poses and viewpoints and the bold distortions that resulted are extraordinary. This very innovative way of working coincided with Rodin's obsession with modern dance during this late period. In an article published in 1912, he claimed that 'dance has always had the prerogative of eroticism in our society. In this, as in other expressions of the modern spirit, women are responsible for the renewal'. Isadora Duncan, another American dancer called Loie Fuller, Diaghilev, Nijinsky, the Japanese actress Hanako, all knew him and posed for him. Isadora Duncan opened a ballet school and brought her students to Rodin's studio so that he could draw them.

In 1906, Rodin followed a group of Cambodian dancers from Paris to Marseille for the same purpose. His ecstatic response to these various dancers' elegant and liberated movement found expression in sculptural form (*Iris*, p. 39) as well as in drawings. When dancers were not available to draw from, Rodin was wealthy enough to employ models.

Many of these drawings of nude models are of an intensely erotic nature; the ones illustrated here are among them. They are unlike anything else by his hand. Rodin had produced erotic drawings at other times and under different circumstances - for book illustrations. He had provided drawings for a privately printed edition of Baudelaire's *Les Fleurs du Mal* (1885) and for a limited folio edition of Octave Mirbeau's *Le Jardin des supplices* (1902); but neither of these even palely matches the later drawings for obsessive, sexual concentration, energy and freedom.

The works by Rodin reproduced in lithograph for Mirbeau's erotic novel do not focus on female pudenda as do the later ones, although they are similar in style. The Baudelaire drawings are also far less explicit and were made in a darker, nervous and more agitated graphic style.

41. *Female Nude with Long Hair Leaning Backwards*.
Graphite and watercolour on cut-out buff paper,
Musée Rodin, Paris.

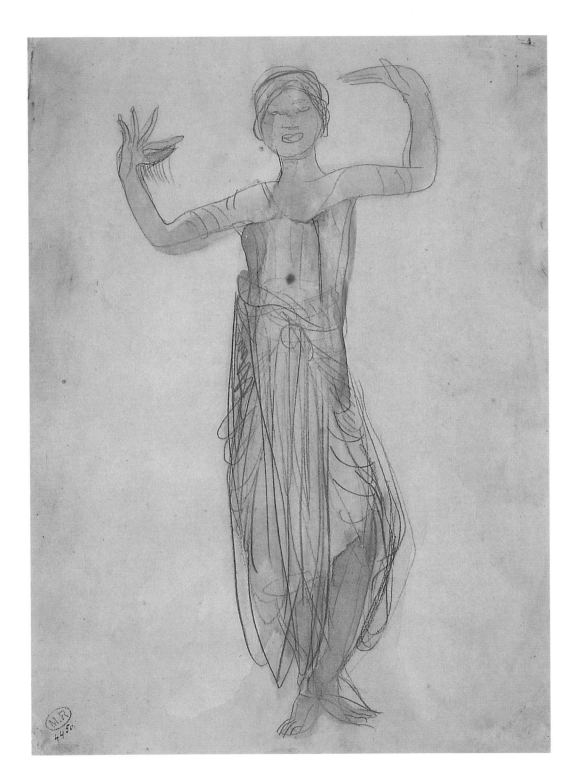

42. ***Cambodian Dancer***
 Standing on the Left
 Leg with Outstretched
 Arms, 1906.
 Graphite stump and
 watercolour with oiled
 pencil on buff paper,
 Musée Rodin, Paris.

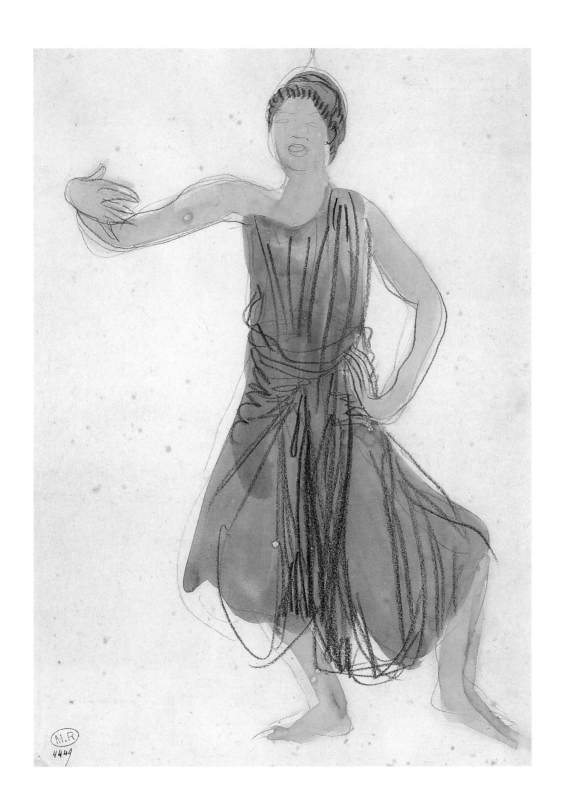

43. ***Cambodian Dancer Standing on the Right Leg with her Left Hand on Hip***, 1906. Graphite, watercolour and gouache with black pencil on buff paper, Musée Rodin, Paris.

Certainly the troubled, painful character of these drawings as well as the sculptures made at around the same time are comparable in mood to the tone and atmosphere both of Baudelaire's poetry and *The Gates of Hell* (p. 6). It seems reasonable to sense in works such as *Je Suis Belle* (p. 35; the title is taken from a poem by Baudelaire; both figures may be also found, separately, on *The Gates*) for example, a guilty or morbid erotic vision in which sexual fulfilment remains unattainable.

The later drawings display nothing of the self-conscious and virtuosic indulgence in such an oppressive expression of darkness, struggle and godlessness. They are of a different order altogether. Principally what distinguishes them is their quantity (generally unknown until quite recently); the fact that the vast majority were never exhibited; the innovative methods by which they were made and the uncompromising, obsessive nature of their subject-matter. Nude, female models are drawn, time after time after time, with legs spread apart. The vulva is placed at the centre of the image - this is the fulcrum or focus, as it were, of Rodin's old age. In some, the models masturbate and either mimic or perform acts of lesbian love. Categorically it seems that Rodin had left behind the guilt and torment of *The Gates* to enter a labial world of uninhibited exuberance and pleasure.

The Hôtel Biron

The theatre for much of this work and activity was the Hôtel Biron in Paris. Originally an eighteenth-century private residence, it had subsequently been owned by the Church and the buildings given over to a convent. In the aftermath of the political and social divisions thrown up by the Dreyfus affair, the French state had formally separated from the Church. As part of this process much Church land was repossessed.

44. *Garden of Pain,* 1898.
Graphite, stump and
watercolour on buff
paper,
Musée Rodin, Paris.

The Hôtel Biron was in a dilapidated condition and the government let it out at low rents. Artists and other more bohemian types rented the old rooms as apartments or studios. The plumbing was hopeless, heating no better; and in the huge, completely overgrown grounds, wild rabbits (rather appropriately) expended their natural energies without check or hindrance.

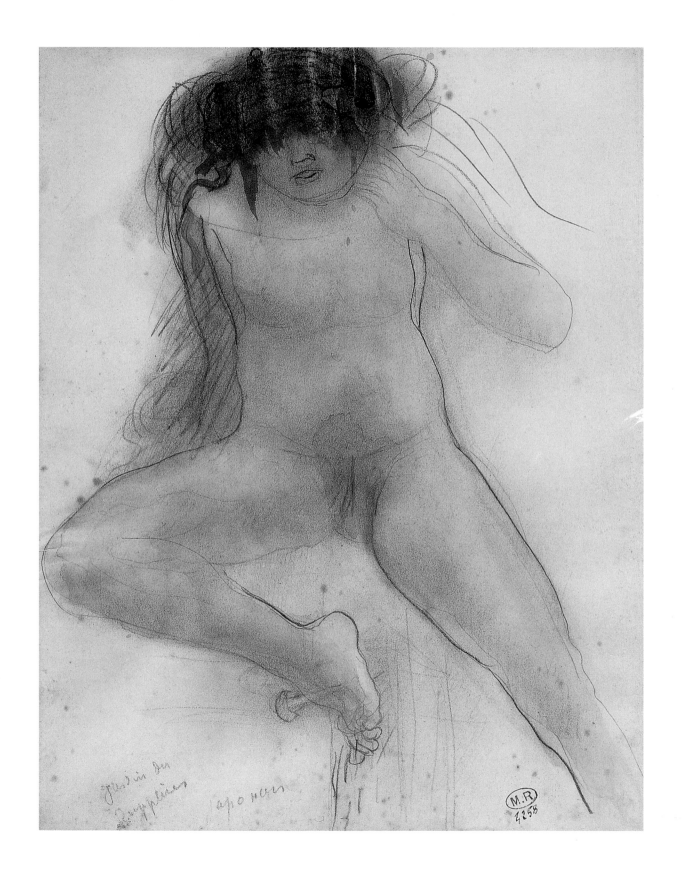

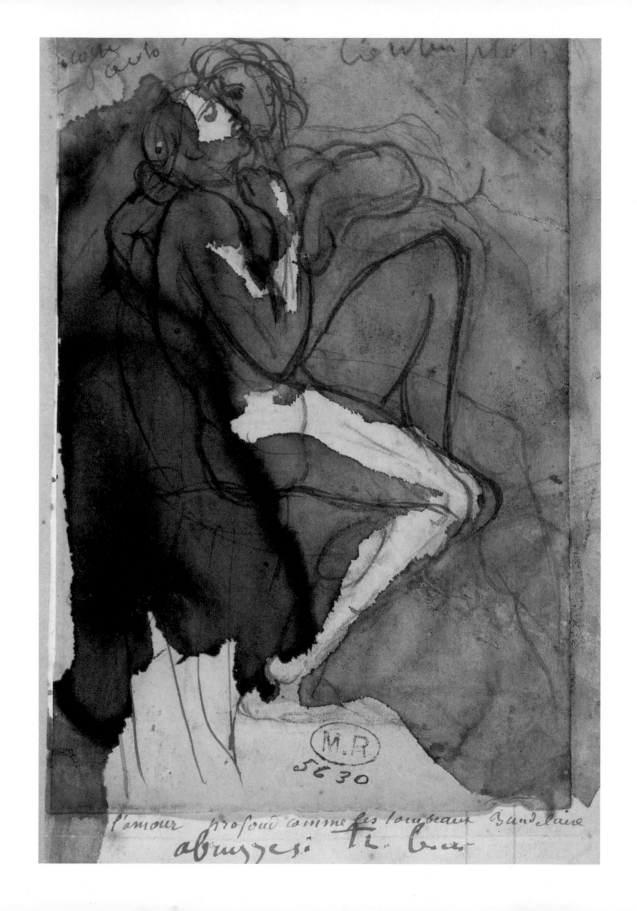

At various times during this colourful period, Rodin's fellow tenants included the dramatist Jean Cocteau, the painter Henri Matisse, the German poet Rainer Maria Rilke (at one time Rodin's private secretary and author of a superb monograph on him), Isadora Duncan and a flamboyant, homosexual actor called Edouard du Max. Du Max converted the sacristy of the convent's chapel into his bathroom; rumours of the nature of Rodin's drawings and of the behaviour of his models, and other scandalous goings-on seeped into the press. Diaghilev found Rodin and Nijinsky fast alseep on the unkempt lawn one afternoon in 1912, after a bibulous lunch; and he circulated reports that Rodin and the dancer were having an affair. There were calls to close the place down. The Hôtel Biron is now the Musée Rodin. Only a fraction of the total number of late erotic drawings are now normally hung together on its walls.

Reactions

Responses to these works have been varied. When a small number of them were shown in Cologne at an exhibition in 1906, the director of the museum concerned was forced to resign because of the furore that ensued. Rodin, as a result, became wary of showing these drawings in public. They were for the most part private works, which have only slowly and fitfully entered the public realm. They have attracted charges of voyeurism and of being merely the fantasies of an impotent old man and they have been dismissed as pornographic. The voyeuristic element is undeniable - the models are not posed so as to solicit any suspension of disbelief in the way, by contrast, that Degas's late nude pastels do: portraying models as lone women washing in the privacy of the bathroom. Degas's models appear to be being spied upon ('through the keyhole' as he put it), while Rodin's figures are clearly only just models - performing and taking their own enjoyment in front of the artist.

The American curator Kirk Varnedoe has described how the process of viewing many hundreds of these drawings together at the other Musée Rodin at Meudon led him through a series of different reactions: surprise, amusement, astonishment, tedium. 'Finally,' he continues, 'I find all my skepticisms defeated. These are not documents of idle self-indulgence, but of heated, driving fascination. The recurrent themes of death and the conflicts of consciousness that compelled the young man's work have here been supplanted, in the spirit of the aging artist, by an ecstatic obsession with the mystery of creation taken at its primal source.'

45. *Drawing*.

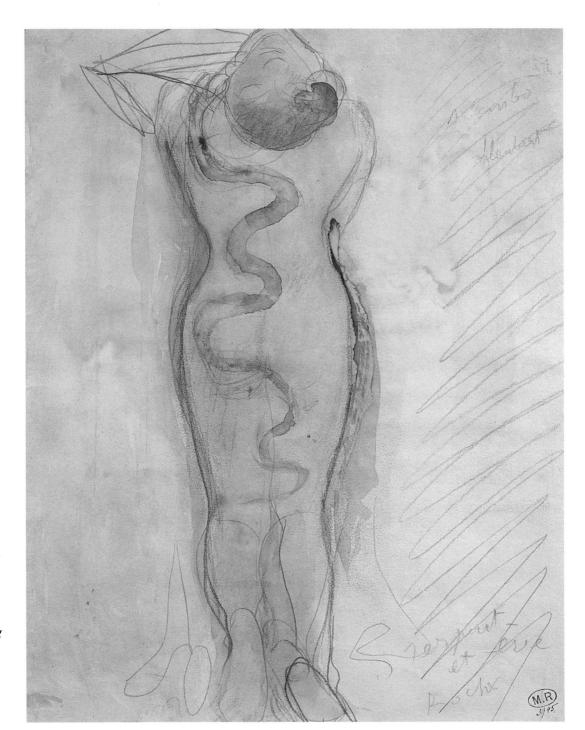

46. *Serpent and Eve*.
 Lead, watercolour and
 gouache on paper,
 Musée Rodin, Paris.

47. *Sapphic Couple Lying
 near the Wheel of
 Fortune*.
 Lead and watercolour
 on paper.

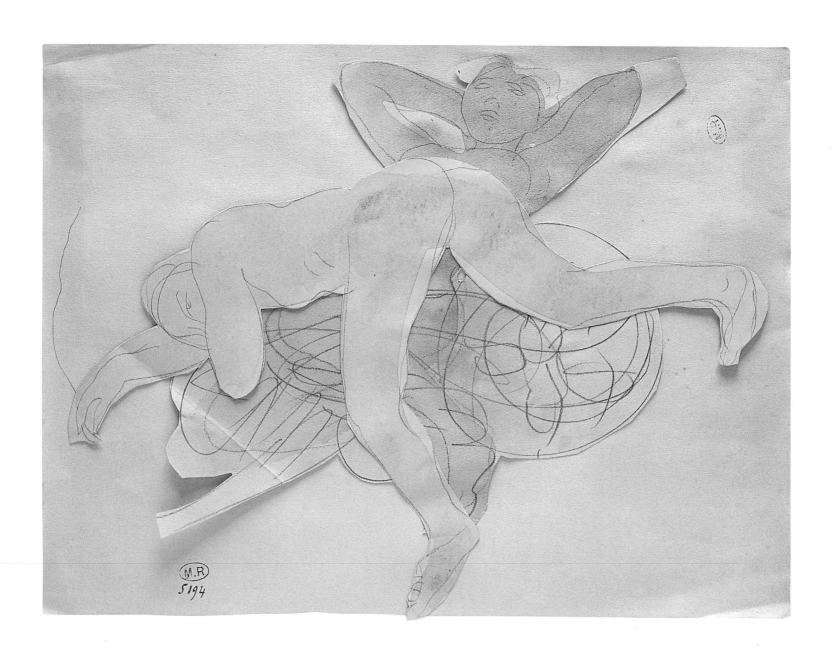

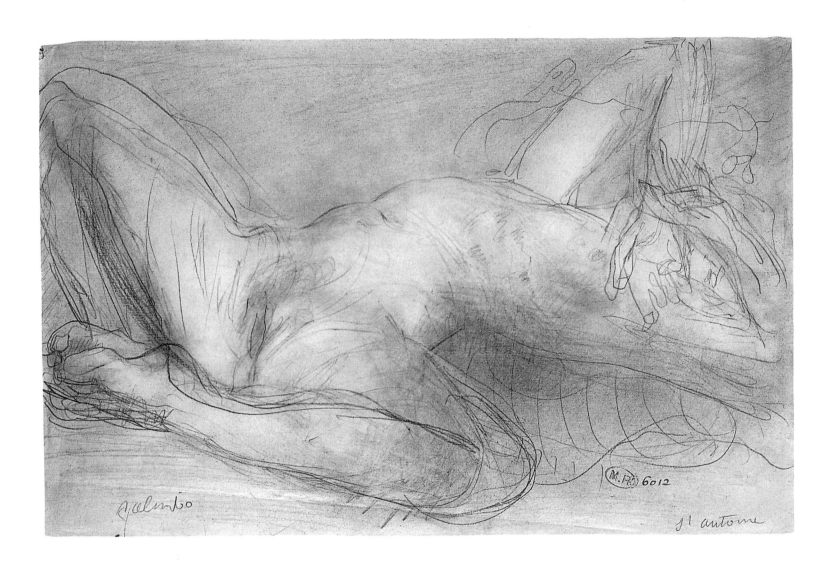

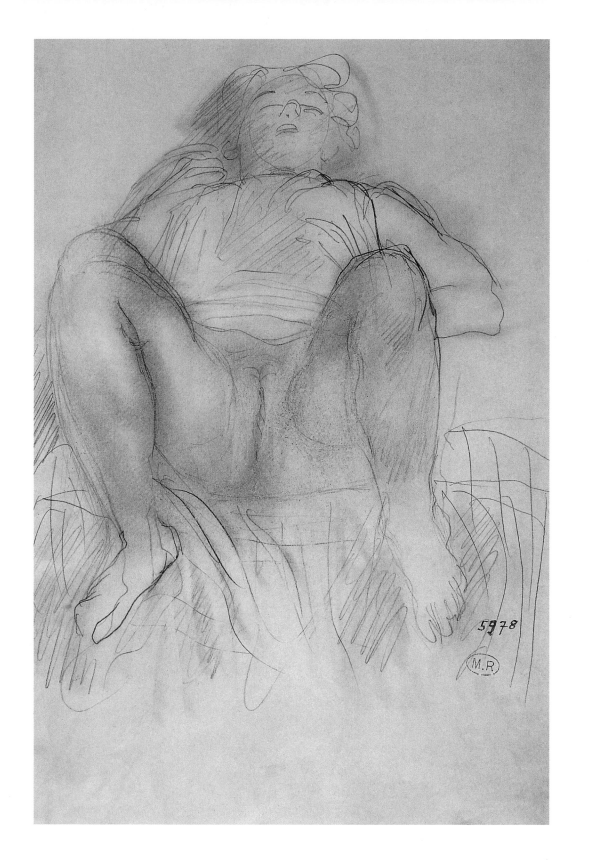

48. *Salammbô*.
Lead and stump on
paper,
Musée Rodin, Paris.

49. **Nude Woman on her
Back, Legs Raised**.
Lead and stump on
paper.

The comparison struck between the younger and older Rodin's work is an interesting one - as if his oeuvre charted a journey in which the earlier obsession with death and suffering is transformed into something very different: a journey from a state of spiritual claustrophobia and struggle to one of liberation and celebration, a journey from *The Gates of Hell* (p. 6) to the doors of life. If such an interpretation is valid, then the issues of voyeurism, male fantasy and the pornographic (with which these drawings have been and are enmeshed) seem to locate themselves, so to speak, less problematically in the background. Rodin himself is recorded as saying towards the end of his life: 'I feel beauty in all its manifestations. The wonder of it overwhelms me afresh every day. I am going to die - I must die - but I am like a tree in full flowering.' When read with the drawings in mind, Rodin's remarks imply that there is something affirmative, creative, uninhibited and joyous within our erotic selves that need not be felt, as it was often enough earlier in his career, as oppressive, febrile or frustrated.

Such a view of Rodin's oeuvre as a whole would place the vitality of the *Balzac* (p. 17) and the late drawings against the morbidity of *The Gates* and many of the pre-1900 sculptures. It does seem, in retrospect, that it was working on the Balzac monument which heralded this alteration in mood. He was to call it 'the sum of my life, my great discovery'. When it was rejected at the Salon in 1898, he removed it to the garden at his home in Meudon. He wanted it for himself.

The *Balzac* was Rodin's last public commission. It was not to be erected in a public space in Paris until over twenty years after his death. In fact most of Rodin's major public commissions failed or were frustrated in one way or another - *Call to Arms* (p. 40) for example, failed to win a competition for a monument commemorating the Franco-Prussian war. *The Gates of Hell*, the great, encompassing work of his maturity, are practically useless - they do not open. The museum for which they were commissioned was never built (what is now the Musée d'Orsay was built in its place). They were not cast in bronze in his lifetime. Neither was Rodin ever paid in full for his work.

Even so, taking his oeuvre as a whole, the range of erotic experience with which it engages is enormous. From conflict, estrangement, struggle and despair, from violence (*L'Emprise*) and seductive grief (*Mary Magdalena at the foot of the Cross*) to the liberation and energy of the last drawings: it is as if all human emotion could be conceived in erotic terms.

50. ***The Temple of Love***.
Lead and watercolour.

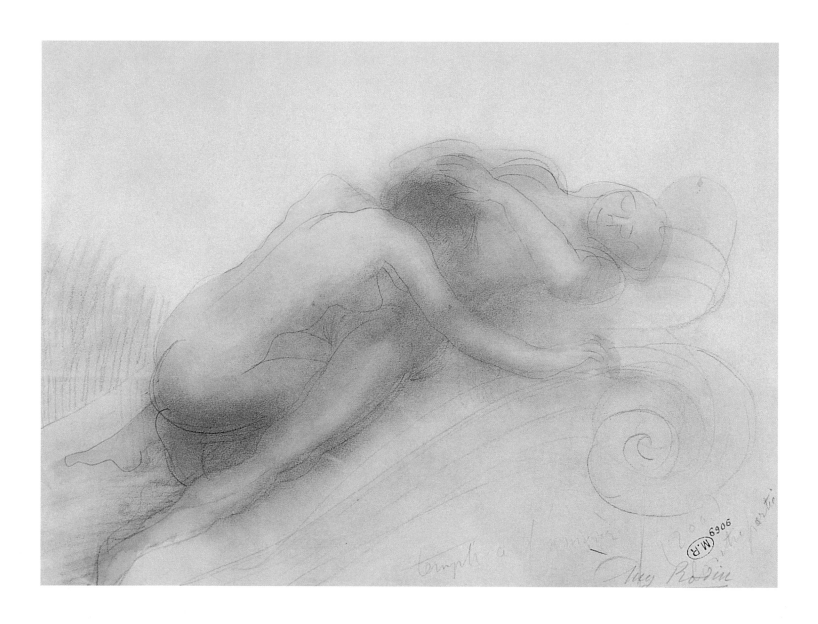

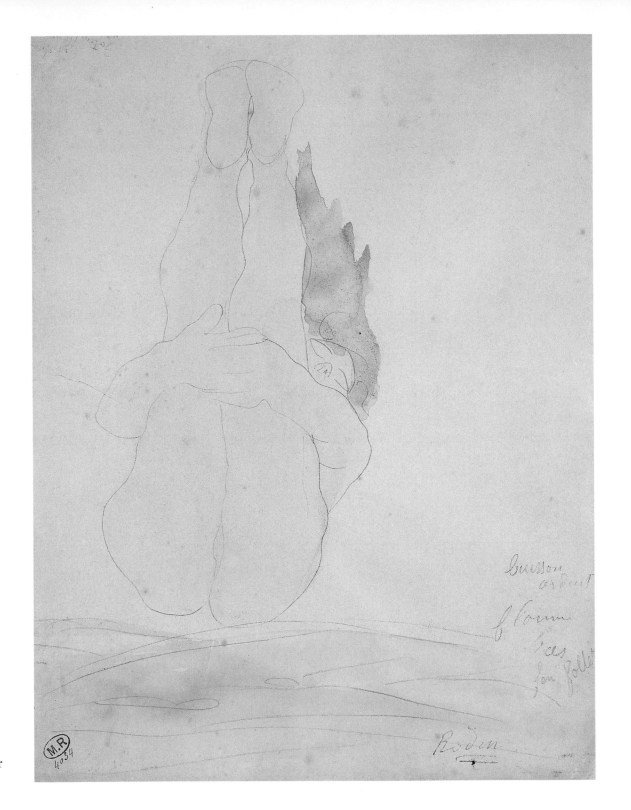

51. *Burning Bush*.
Lead and watercolour
on paper.

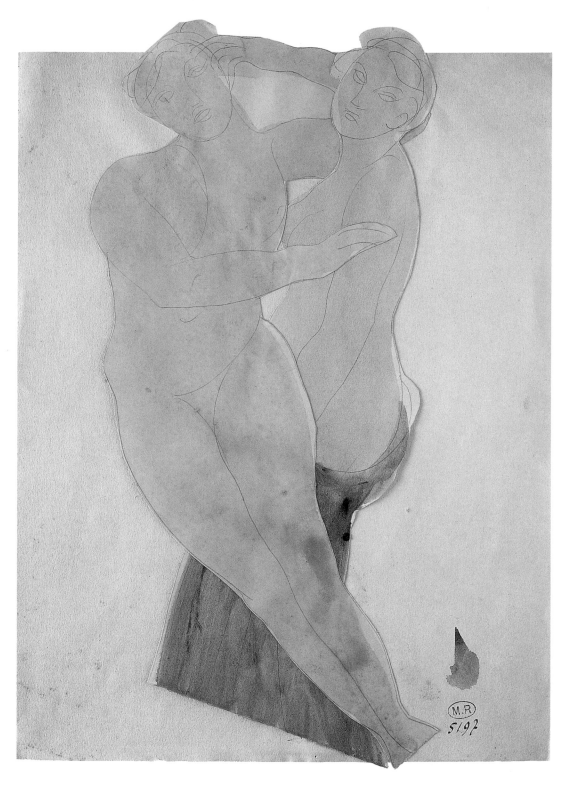

52. *Two Women Embracing*. Lead and watercolour on paper.

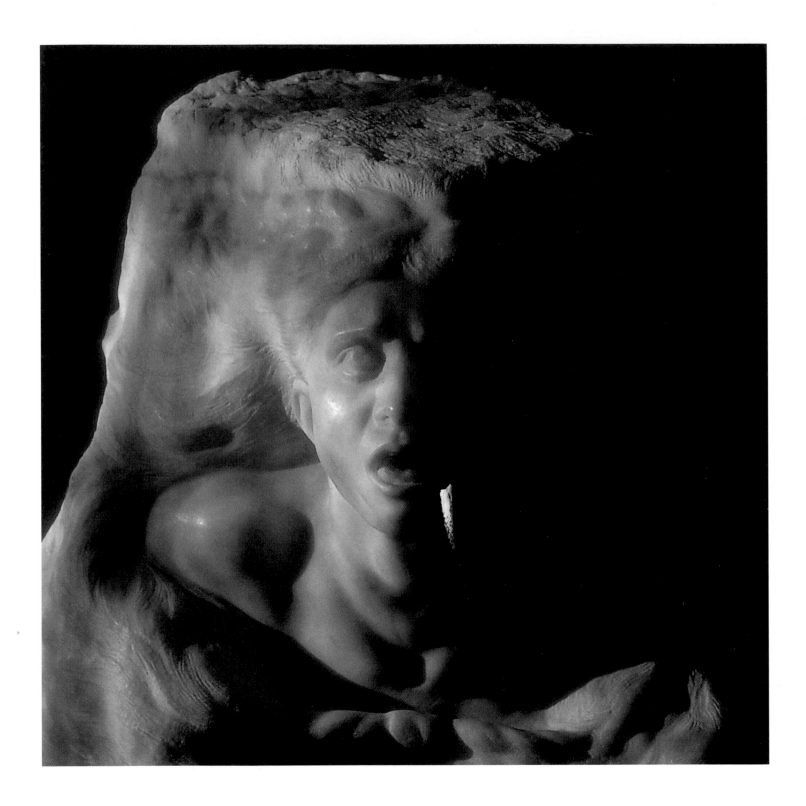

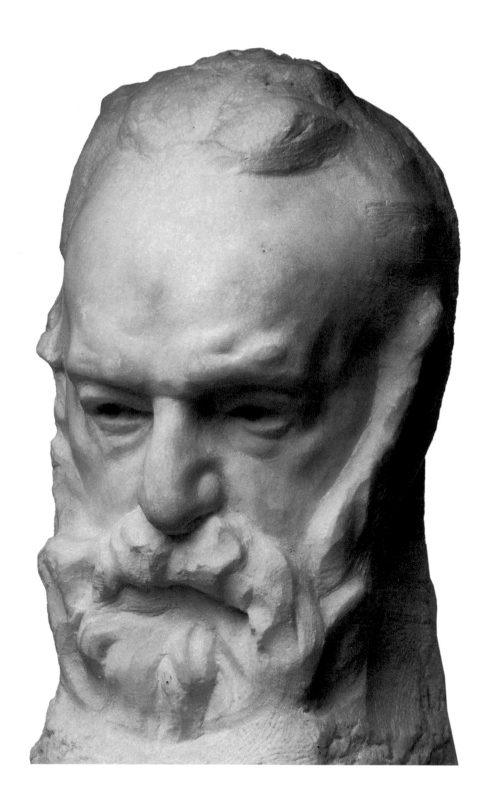

53. *The Tempest.* Marble.

54. ***Bust of Victor Hugo***,
 1883.
 Marble,
 Musée Rodin, Paris.

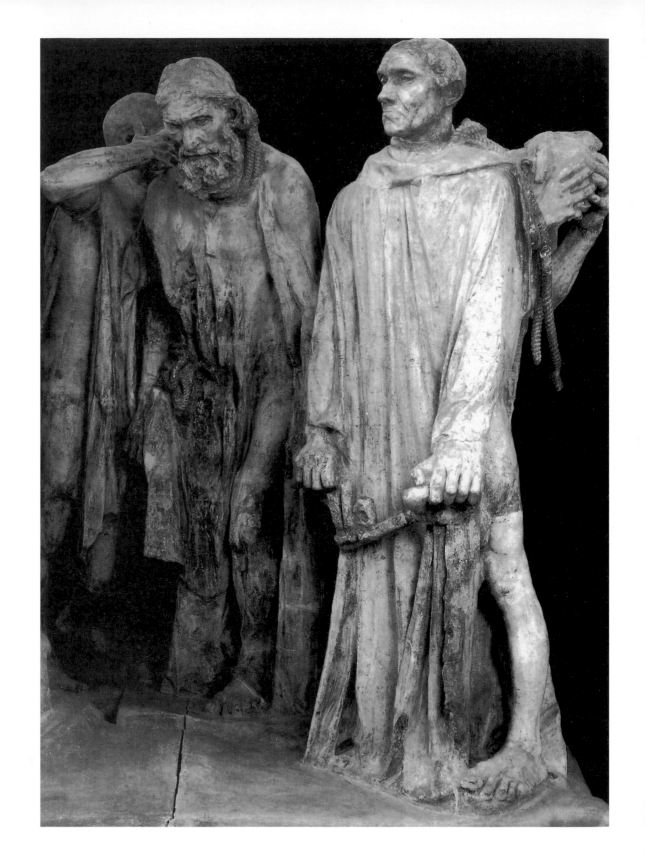

55. *The Burghers of
 Calais*, 1889.
 Plaster, left part,
 Musée Rodin, Paris.

56. *The Burghers of
 Calais*, 1889.
 Bronze,
 Musée Rodin, Paris.

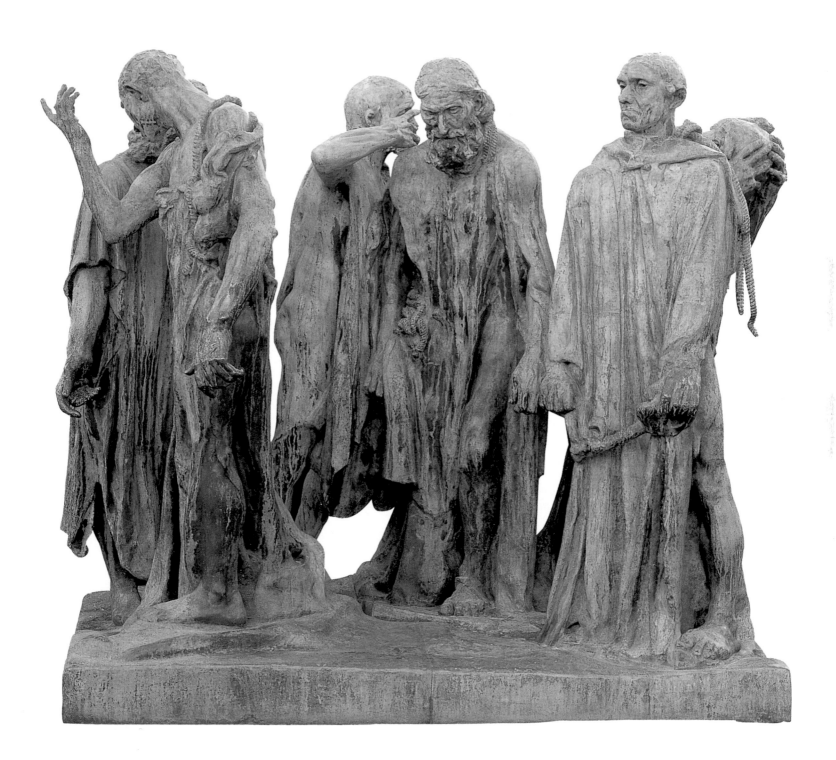

A decidedly iconoclastic twentieth century artist, Jean Arp, wrote a short poetic tribute to Rodin, in which he lamented the advent of what he called the 'érotomachie mécanique de notre siècle', comparing this development wistfully against Rodin's more humane achievements within an erotic sphere. So as not to be disturbed, Rodin himself used to pin a notice to the door of his studio when otherwise engaged with one of his models: 'Monsieur Rodin is away visiting cathedrals.' And in a figurative sense the statement was not untruthful. For the human body, in particular the female, was a temple for him. 'The dazzling splendour revealed to the artist by the model that divests herself of her clothes has the effect of the sun piercing the clouds. Venus, Eve, these are feeble terms to express the beauty of woman,' he is recorded as saying by his earliest biographer.

As is clear in the way he composed *The Gates* (p. 6), Rodin did not feel obliged to follow any paths set down already by literature. In fact, in other works he often only added literary or mythological titles once the figures had already been modelled. On occasion he seems deliberately to have ignored his literary source: in *Hand of God* (p. 37), Rodin models the divine hand caressing Woman or Eve into existence; she is born, not from Adam's rib, but as an independent creature in her own right.

From the forthright advances of Francesca in *The Kiss (p. 4)*, to the man's submission before his muse in *Eternal Idol* and, finally, in the late erotic drawings, it seems that, perhaps, the most relevant legacy the erotic explorations of his work (if not his life) have left us is this: of woman as the sexual equal of man.

57. ***The Three Shades***,
 before 1886.
 Bronze,
 Musée Rodin, Paris.

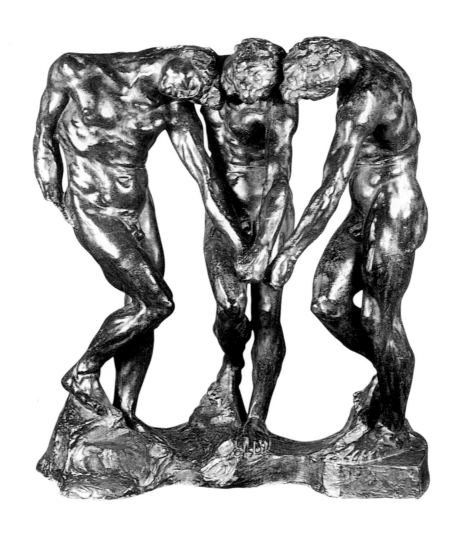

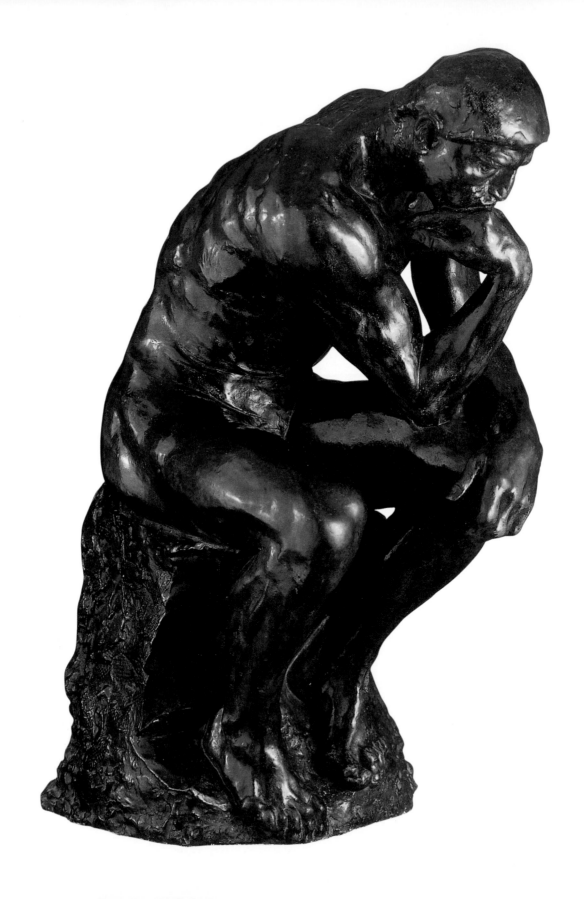

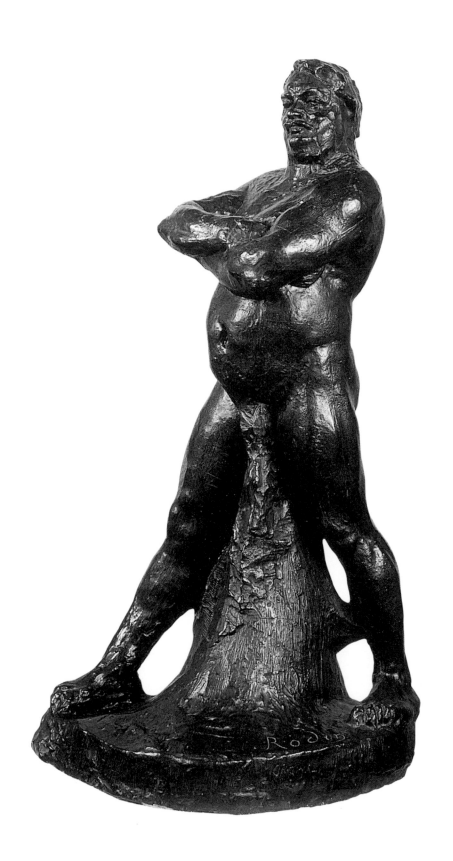

58. *The Thinker*,
 1880-1881.
 Bronze,
 Musée Rodin, Paris.

59. *Balzac, Nude*
 Study C, 1892-1893.
 Bronze,
 Musée Rodin, Paris.

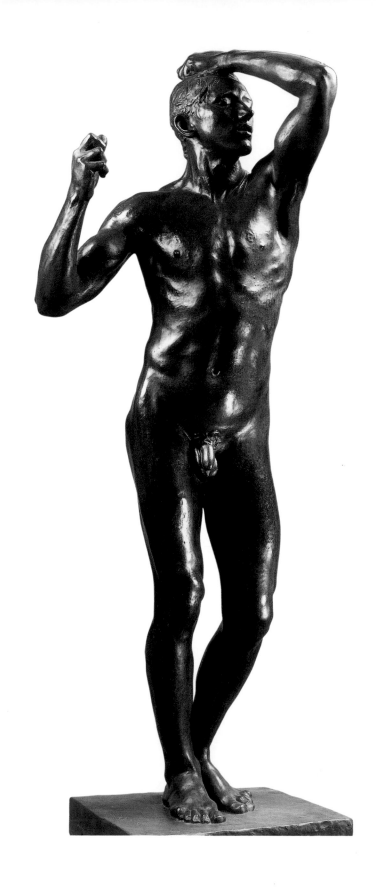

BIOGRAPHY

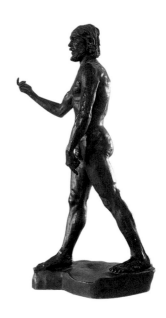

1840:
Birth of Auguste Rodin in Paris on November 12th.

1850:
Rodin starts to draw.

1854:
He enters into a special school for drawing and mathematics, called "La Petite Ecole", and takes classes from Lecoq de Boisbaudran and the painter Belloc.

1855:
Rodin discovers sculpture.

1857:
He leaves "La Petite Ecole" and attempts to enter into the School of Fine Arts, but is rejected three times.

1862:
Death of his sister Maria. Grief stricken by her death, Rodin goes to the Très-Saint-Sacrement, a Catholic Order, where he stays until 1863.

1864:
Beginning of the collaboration with Carrier-Belleuse.

1872:
End of his collaboration with Carrier-Belleuse.

1873:
He enters into a contract with Belgian sculptor Antoine-Joseph van Rasbourgh.

1875:
Goes to Italy where he sees the works of Michelangelo.

1877:
He exhibits *The Age of Bronze* in Brussels and then in Paris at the French artists' Salon. Rodin is accused by critics of having cast a mould from a live model.

60. *The Age of Bronze*,
 1877.
 Bronze,
 Musée Rodin, Paris.

61. *Saint John the*
 Baptist, 1880.
 Bronze,
 Musée Rodin, Paris.

1880:

The state buys *The Age of Bronze* and asks Rodin to design a door for the future Museum of Decorative Arts. He will work on the project for the rest of his life, although the museum was never built.

1881:

He learns engraving with Alphonse Legros in London.

1882:

Rodin does the figures of *Adam, Eve* and *The Thinker.*

1883:

He meets nineteen-year-old Camille Claudel.

1885:

The Municipal Court of Calais commissions a commemorative monument to Eustache de Saint Pierre, which will become the *Monument to the Burghers of Calais,* inaugurated in Rodin's presence in 1895.

1887:

He is named a knight in the Legion of Honour.

1888:

The state commissions *The Kiss,* in marble, for the Universal Exposition of 1889.

1889:

He is a founding member of the National Society of Fine Arts.

1890:

The project *Monument to Victor Hugo* for the Pantheon (*Victor Hugo seated*) is refused.

1891:

A new model for the *Monument to Victor Hugo* (*Victor Hugo standing*) is designed and the Society of Men of Letters commissions a *Monument to Balzac.*

1898:

Splits with Camille Claudel, then aged 34. The Society of Men of Letters refuses the *Monument to Balzac* in plaster.

62. *The Cathedral*, 1908.
 Stone,
 Musée Rodin, Paris.

1899:

First expositions in Brussels, Rotterdam, Amsterdam and The Hague.

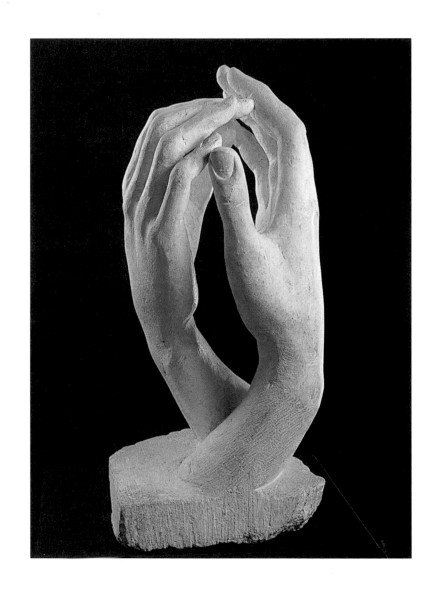

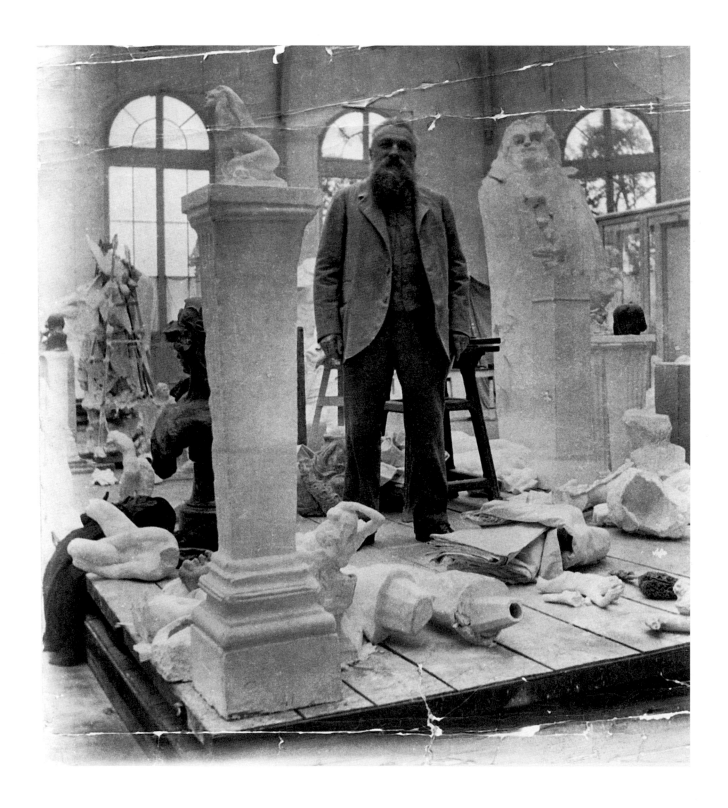

1902:
Rodin meets the poet Rainer Maria Rilke (1875-1926), who will be his secretary from September 1905 until May 1906.

1904:
Rodin meets the Duchess of Choiseul with whom he splits with in 1912. First exhibition of *The Thinker* (plaster/large model) at the International Society of London and then at the Paris Salon (bronze). He has an affair with Gwendolen Mary John. She becomes his mistress and serves as his model for *Whistler's Muse*.

1905:
Rodin is nominated a member of the Superior Council of Fine Arts.

1906:
The Thinker is placed in front of the Pantheon. Rodin does a series of watercolours of Cambodian dancers and exhibits them at Marseille's Colonial Exposition.

1907:
First big exhibition devoted solely to his drawings is at the Bernheim Jeune Gallery in Paris.

1908:
Moves to the Hôtel Biron (now the Musée Rodin) in Paris.

1910:
Rodin is made a commander of the Legion of Honour.

1913:
Confinement of Camille Claudel. Exhibition at Paris Faculty of Medicine where the older works of Rodin's collection are shown for the first time.

1914:
Rodin flees during the war and leaves for England and then Rome.

1916:
Rodin falls seriously ill. The State gives three successive donations to Rodin's collections.

1917:
Rodin marries Rose Beuret on January 29th, but she dies shortly afterwards on February 14th, not long before Rodin himself, who passed away on November 17th. *The Thinker* sits at the base of their tomb.

63. *Rodin in his studio*.
Anomymous
photograph,
Musée Rodin, Paris.

LIST OF ILLUSTRATIONS